NEW ENGLAND
NEON

NEW ENGLAND
NEON

SUSAN MARA BREGMAN

ARCADIA
PUBLISHING

Copyright © 2018 by Susan Mara Bregman
ISBN 9781540235725

Published by Arcadia Publishing
Charleston, South Carolina

Library of Congress Control Number: 2017963440

For all general information, please contact Arcadia Publishing:
Telephone 843-853-2070
Fax 843-853-0044
E-mail sales@arcadiapublishing.com
For customer service and orders:
Toll-Free 1-888-313-2665

Visit us on the Internet at www.arcadiapublishing.com

For the amazing community of sign geeks
whose work inspires me every day.

CONTENTS

ACKNOWLEDGMENTS

This book was born on a streetcar. As I was heading into Boston on the MBTA Green Line, late in December 2015, a thought popped into my head: I want to write a book about neon signs in the new year. It took a little longer, but I hope it was worth the wait.

So, thank you, Massachusetts Bay Transportation Authority. Those long hours spent on the Green Line finally paid off.

Thank you to the many sign spotters who accompanied me on trips in southern New England: Nicki Rohloff, Tom Cohan, Liz Budington, Alisa Capaldi, Bob Brodesky, and Cindy Sragg. You waited patiently in your cars while I framed a shot, expertly navigated free-for-all rotaries, provided backup in sketchy neighborhoods, and risked food poisoning at least once. And a shout-out to my virtual sign spotters, Janet Cohan and Colleen Watson, both of whom delighted in sharing their discoveries from the road.

Thank you to the friends and family who listened to my endless obsessing (some might say whining) about this project and kept me centered, especially David Dao, Susan Compernolle, and Gloria Leipzig.

Thank you to Anne Quirk for her keen editorial eye (and inspired restaurant choices).

Thank you to the business owners, neon experts, and roadside enthusiasts who graciously answered my questions and filled in the blanks about the stories behind some of these signs. Librarians, archivists, and public officials also provided invaluable support, and I thank them for their resourcefulness in tracking down even the most obscure details.

Thank you to the team at Arcadia Publishing, including Caitrin Cunningham, Erin Vosgien, Ryan Easterling, and Katie Parry.

Finally, thank you to my old friend Tom Wagner, who was not around for this chapter in my life but always saw the best in me.

Except for a few clearly identified images, I took all the photographs in the book. Photographs indicated MIT in the text are from the Kepes-Lynch Photograph Collection (Copyright © Massachusetts Institute of Technology; photograph by Nishan Bichajian). Photographs indicated City of Boston are from the Mayor John F. Collins records, Collection No. 0244.001, City of Boston Archives, Boston.

INTRODUCTION

The neon sign was born on January 19, 1915—truly a red-letter day (and blue, green, and yellow). On that date, French inventor Georges Claude received a United States patent for his system of illuminating by luminescent tubes.

Neon lights are sealed tubes filled with certain gases—often, but not always, neon—with an electrode at each end. The gas glows in the presence of an electrical current. The color of the light depends on the mix of elements inside the tube and the use of phosphors to line the glass. Neon gas glows a familiar red-orange, for example, while blue lights usually come from a combination of argon gas and mercury vapor.

Claude was not the first to work with electrified gases—other European scientists began experimenting with the process in the 19th century—but he was the first to exploit its commercial possibilities.

A Packard car dealership in Los Angeles is often credited with installing the first commercial neon sign in America, less than a decade after Claude received his patent, in 1923. People were said to drive miles to marvel at the modern technology, popularly dubbed "liquid fire," and police reportedly were called in to manage the crowds. But researchers have lately cast some doubt on that tale, proposing that neon signs instead made their debut in New York City or possibly San Francisco.

No matter where they started, neon signs quickly found their way to New England, where they lined main streets and back roads, illuminated theater marquees and doughnut shops, and directed patrons to gas stations and bowling alleys.

Today, some people dismiss neon signs as rusty roadside relics. But they are much more. Neon signs represent the intersection of art, science, and commerce.

Neon signs are individual works of art. They are handmade by artisans, known as sign benders, who painstakingly create one-of-a-kind displays.

Neon signs are magical, using science to transform downtowns and highways into extravagant showcases of color and motion.

Neon signs are time-travel machines, bringing us back to an era of mom-and-pop businesses where the waitress and the grill man knew their customers and how they liked their eggs.

Neon signs have tales to tell about the American dream, served up one doughnut at a time.

Neon signs remind us of special times: ice cream on a sweltering summer night, celebrations at a favorite restaurant, or first dates at a downtown movie palace.

In short, neon signs matter.

I covered thousands of miles in cars, trains, buses, and even ferries to research these signs. Sometimes I traveled with sign-spotting friends, and other times I was on my own. I tried the corned beef hash at as many diners as possible, saw an elephant on a rooftop in Maine, and traversed my first covered bridge in New Hampshire. But my favorite part of tracking down these vintage beauties, aside from encountering the magical words "breakfast all day," was finding patterns and drawing connections.

Some themes crossed state lines. Enterprising Rhode Island restaurateurs created the New York System hot "weiner." The Coney Island hot dog, a similar delicacy, settled into Worcester, Massachusetts. Perhaps in celebration of the region's long history, New England is full of Colonial Theaters. The oldest of these illuminated their venues with incandescent lights, but others had lovingly restored neon marquees.

Many diners employed a naming strategy to better attract women customers by feminizing their location. The Miss Florence Diner, known locally as "Miss Flo," had the most exuberant sign, but I also encountered Miss Portland, the newly refurbished Miss Mendon (née Miss Newport), and several of their non-neon sisters. Not surprisingly, many of the diners in New England were manufactured locally by the Worcester Lunch Car Company (WLCC). WLCC built 651 diners between 1906 and 1957, and each one had a serial number. I included those numbers in the text when available.

I also enjoyed the "o-ramas"—not to mention the "a-dromes"—popular mid-century linguistic twists that pepped up everything from bowling alleys to hot-dog joints. (Yes, there is a Wein-O-Rama in Cranston, Rhode Island.) Speaking of that Cranston spot, neon signs also document regional expressions that are largely unknown outside New England—the liquor markets known locally as package stores, the old-school dry cleaners doing business as cleansers, and Rhode Island's affinity for hot "weiners" (not "wieners," which is the standard spelling). Signs also showcase changing fashions in architecture and industrial design, as the lavish Art Deco signs of the 1930s gradually gave way to streamlined versions in the 1940s, which in turn were supplanted by the playful Googie style of the 1950s and 1960s.

Again and again I saw the power of community action, as neighborhoods banded together to save their historic movie palaces from the wrecking ball or to rebuild a local restaurant after flood or fire. But preservation takes commitment and money, and I also saw theaters sitting vacant in the middle of otherwise vibrant main streets and "for sale" signs on old diners. The number of bowling alleys and drive-ins is dwindling, falling victim to changing tastes in entertainment and rising real estate values. Independent motels are also disappearing, vulnerable to the impact of the interstate highway system and the growth of national chain lodging.

The signs on the following pages range from the widely celebrated, like Boston's CITGO sign, to anonymous shops that have faded into obscurity. They include diners and doughnut shops, bowling alleys and roller rinks, drive-ins and filling stations. I also included a mix of daytime and nighttime photographs. Neon signs are meant to be seen after dark, but the elements visible in daylight—tubes, electrodes, fittings, painted letters, and even the rust—are also part of their story.

Many of the neon signs in this book are still shining bright at their original locations—although they may have had a face-lift or two. Others have become awkward hybrids, combining vintage neon with newer plastic elements. A few of the signs pictured here are updates of originals that were too damaged to repair or too costly to operate. Some sign owners restored the neon, perhaps modifying the display to reflect new ownership or messaging, but others replaced the original tubes with light-emitting diode technology, known as LED. I included only faithful reproductions that adhered to the spirit of the originals.

But those are the happy endings. Many of New England's neon signs have gone dark, victims of time, weather, and neglect. Far too many have disappeared without a trace, sometimes just weeks after I clicked the shutter, and others are endangered. I hope this book helps readers recognize the beauty and significance of New England's neon legacy and inspires them to keep the signs glowing for years to come.

New England Neon is a personal and affectionate look at the best and the (not always) brightest signs in the region. My goal was to be representative, not exhaustive. But every sign I included in this book has a story to tell, and I am delighted to share those tales.

One

MASSACHUSETTS

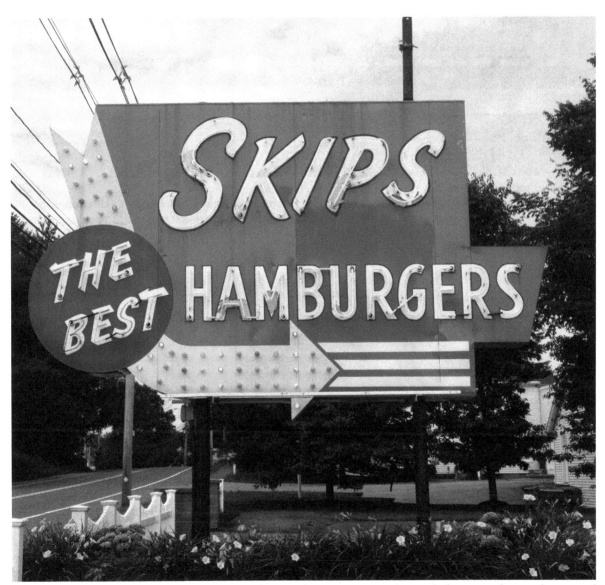

Skip's Snack Bar, located in Merrimac, Massachusetts, boasts a spectacular roadside sign with neon letters and flashing arrows. The family-owned restaurant opened in 1947 and is famous for two things: hand-cut curly French fries and cruise nights. On several Saturday evenings each summer, Skip's invites owners and collectors of vintage cars for a few hours of food, festivities, and fundraising for local charities.

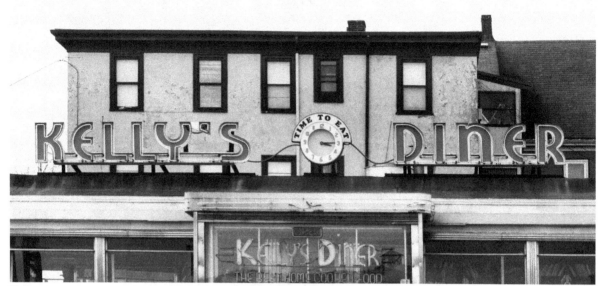

Kelly's Diner was manufactured by the Jerry O'Mahony Diner Company in 1953. The two-piece diner was 55 feet long and one of the largest diners of its time. Originally located in New Castle, Delaware, the diner was transported to the Ball Square neighborhood of Somerville, Massachusetts, in 1996, where it was reassembled and renovated.

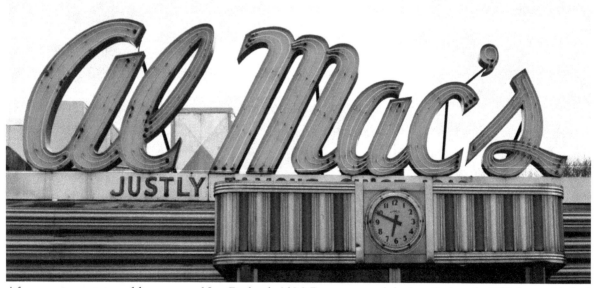

After opening a string of diners across New England, Al McDermott saved the best for last. In 1953, he established Al Mac's diner—which he named after himself in giant blue neon letters—in Fall River, Massachusetts. The stainless steel DeRaffele diner was placed in the National Register of Historic Places in 1999 and is currently operated by the Dunse family.

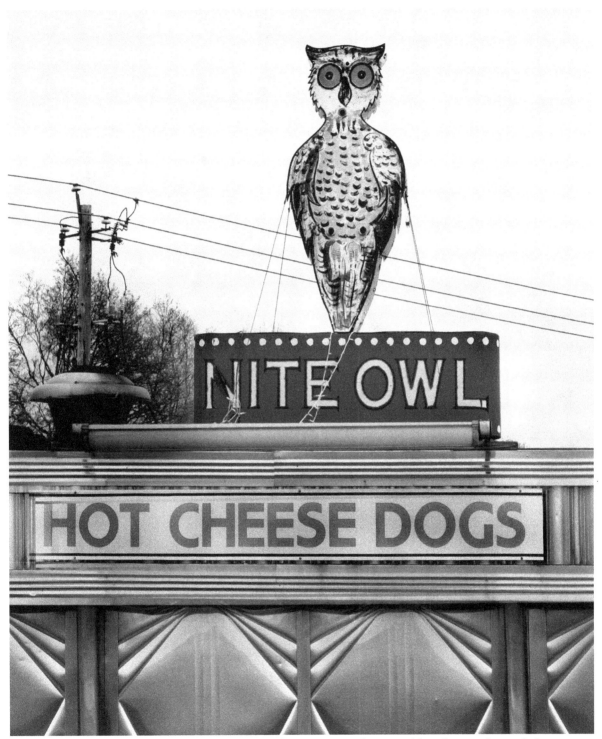

Not much is known about the Nite Owl Diner in Fall River, Massachusetts, although some diner scholars suspect that Al McDermott, of Al Mac's, was the original owner. Now abandoned for more than a decade, the DeRaffele diner replaced a smaller Worcester Lunch Car model (No. 786) in 1956.

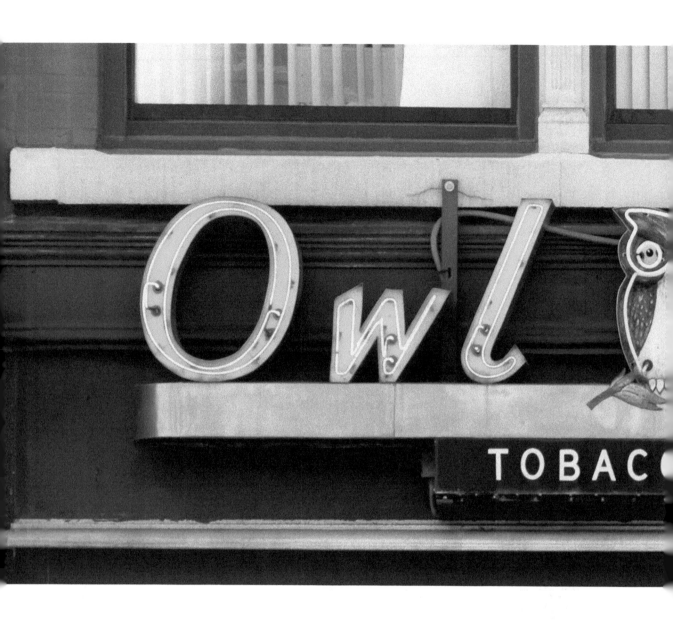

A winking neon bird watches over the Owl Shop, opened by tobacconists George Photakis and his brother-in-law Joseph St. John in 1946. Zack Photakis runs the store today, marking a third generation of family ownership for this enterprise in Worcester, Massachusetts.

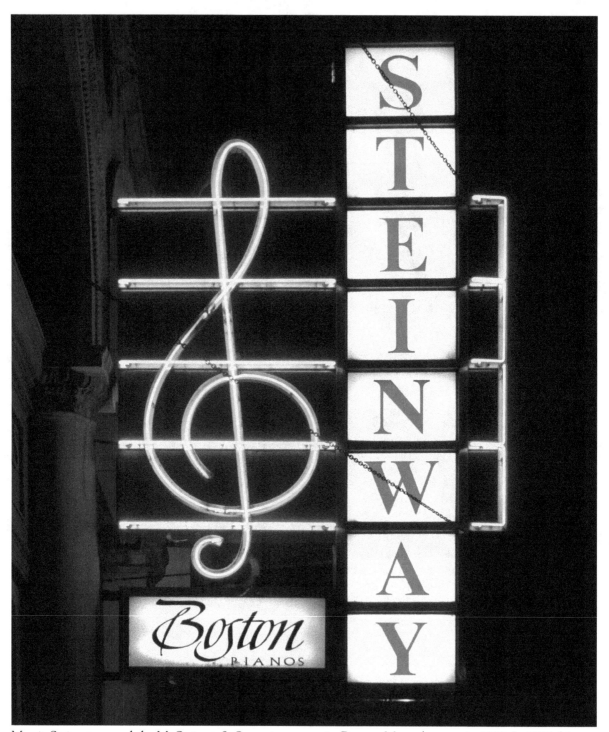

Morris Steinert opened the M. Steinert & Sons piano store in Boston, Massachusetts, in 1880. In 1886, his son Robert Steinert commissioned a new building, which included Steinert Hall, an underground concert venue shuttered since the 1940s. Ownership of the company eventually passed to Jerome Murphy, who began as a bookkeeper in 1897, and a fourth generation of the Murphy family works in the business today.

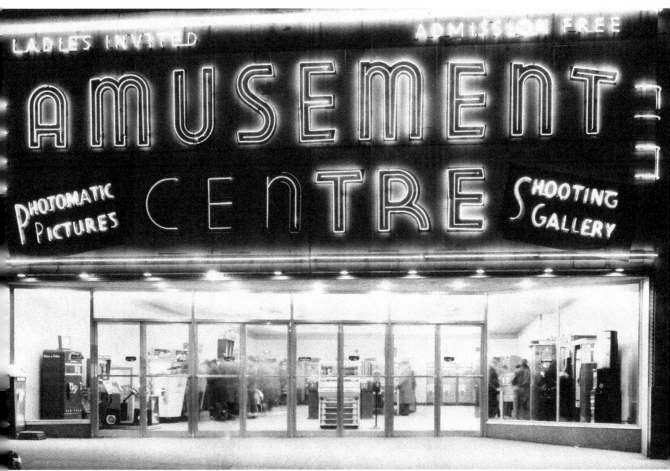

Scollay Square was Boston's entertainment district, a mix of burlesque theaters (including the storied Old Howard Theatre), tattoo parlors, and seedy bars. The Amusement Centre opened in 1942, one of several penny arcades in the Massachusetts capital. Scollay Square was demolished in 1962 and replaced with city, state, and federal buildings as part of Boston's Government Center. (Courtesy of MIT.)

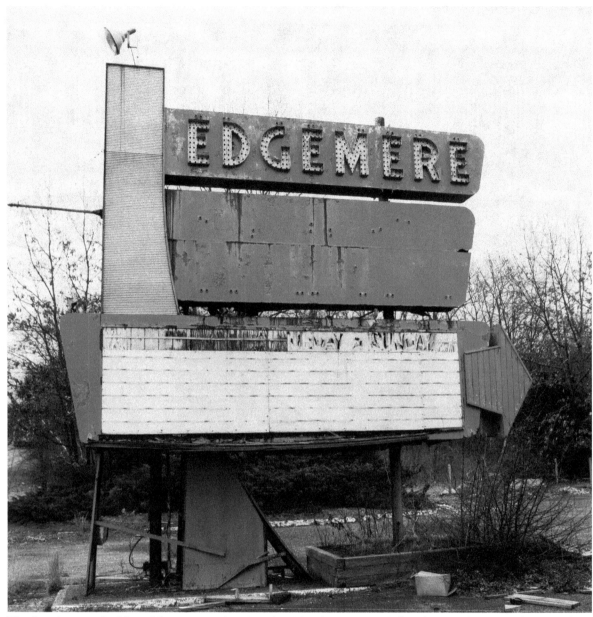

The first drive-in the United States opened in Camden, New Jersey, in 1933, but the new theaters did not catch on until in-car speakers became available about a decade later. By 1958, the number of drive-ins peaked at 4,063, but now fewer than 400 remain. The Edgemere Drive-In Theatre opened on US Route 20 in Shrewsbury, Massachusetts, in 1955 and closed in the early 2000s. The site was still vacant in 2017, although several development projects have been proposed since the theater closed.

The most beloved sign in Boston does not mark a colonial battle or commemorate a cultural milestone. It touts a petroleum company. Erected in Kenmore Square in 1965, the CITGO sign replaced a 25-year-old Cities Service sign as part of a corporate rebranding campaign. The double-faced sign originally had more than 5,000 neon tubes, but they were replaced by LEDs in 2005.

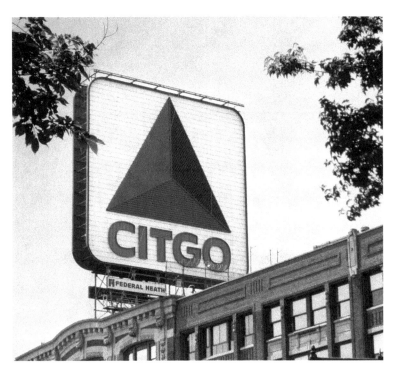

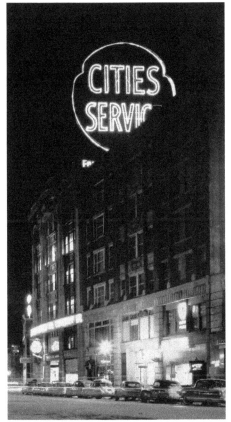

The first hint of the sign's popularity came in 1982 when a public outcry prevented CITGO from taking it down. Saved from the scrapyard, the sign achieved iconic status and began appearing on T-shirts, postcards, and other merchandise. When a 2016 real estate deal threatened the neon icon again, city officials brokered an agreement to keep it in place for years to come. A decision on city landmark status was still pending in 2017. (Courtesy of MIT.)

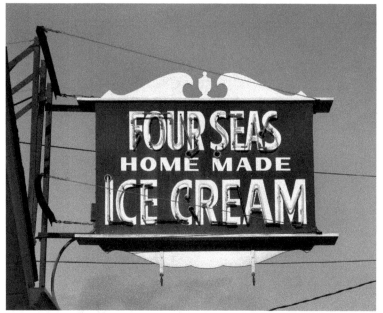

In 1934, Boston insurance salesman W. Wells Watson invested in an ice-cream business, which was housed in an old blacksmith shop in Centerville, Massachusetts. He hired Richard Warren to manage Four Seas Ice Cream in 1956 and sold it to him four years later. Warren ran the Cape Cod operation for 40 years, and his son Douglas continues the family tradition today.

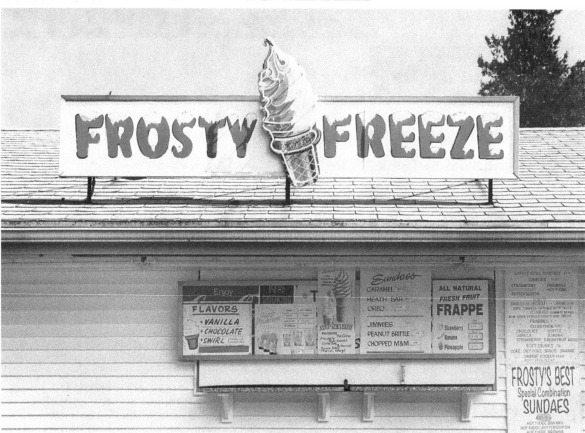

Tucked between a used car lot and a fast-food restaurant in Boston's Roslindale neighborhood, Frosty Freeze serves frappes, cones, and sundaes and offers, as the neon ice-cream cone says, "Best licks in the east."

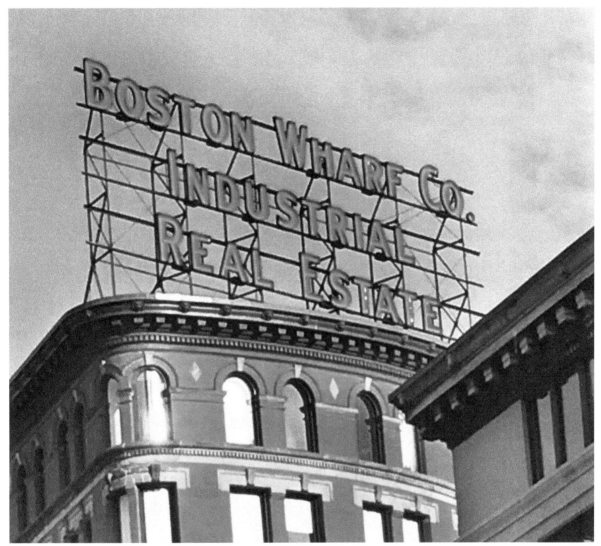

Incorporated in 1836, the Boston Wharf Company purchased land and the adjoining flats in the city's South Boston neighborhood to build a series of wharves and warehouses. By the start of the 20th century, Boston Wharf created a new industrial district supporting everything from shoe manufacturers to candy factories. The area is now known as the Fort Point Channel Historic District—named after the body of water that separates it from downtown Boston—and is home to a mix of artist lofts, technology companies, and restaurants. The district was added to the National Register of Historic Places in 2004 and designated a Boston historic district in 2009.

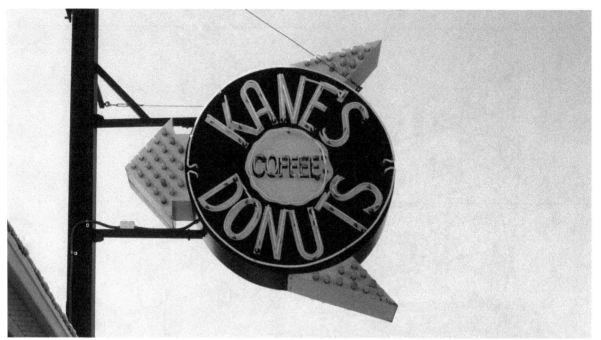

Bob and June Kane opened their namesake doughnut shop in Saugus, Massachusetts, in 1955. Peter and Kay Delios purchased Kane's in the late 1980s, and today, their five children carry on the family tradition. The shop prepares its doughnuts fresh daily from local ingredients—even the boxes are local—using family recipes.

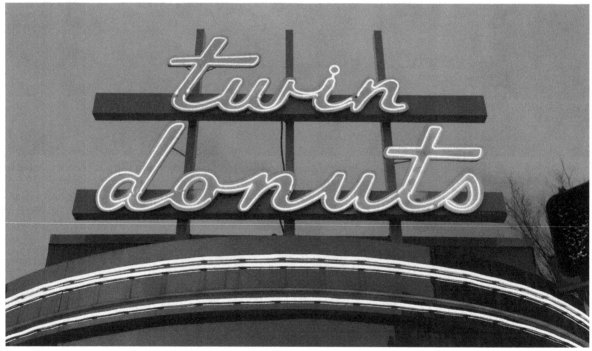

Twin Donuts opened in the Union Square section of Allston, Massachusetts, in the 1950s. Accounts vary, but the shop was likely named after the twin sons born to the owner of the nearby Model Café in 1953. Sou Pang and her husband bought the business in 2001, and she runs it today with the help of her children.

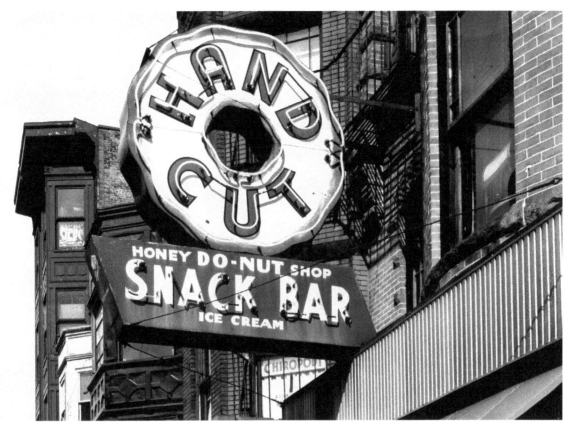

Neon signs and doughnuts make a sweet combination. This photograph from the 1950s shows the sign for the Honey Do-Nut shop in Cambridge, Massachusetts. (Courtesy of MIT.)

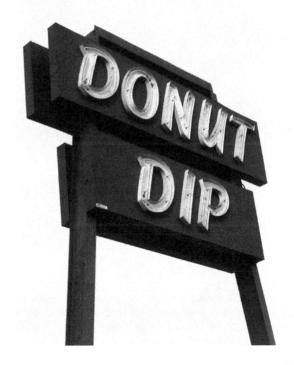

Donut Dip's distinctive neon pylon sign has been welcoming customers to this fourth-generation sweet spot for more than 50 years. Charles Shields and his son Richard opened the shop in West Springfield, Massachusetts, in 1957. Richard's son Paul joined the family business in the 1980s, and his daughter Katie began working behind the counter in 2013.

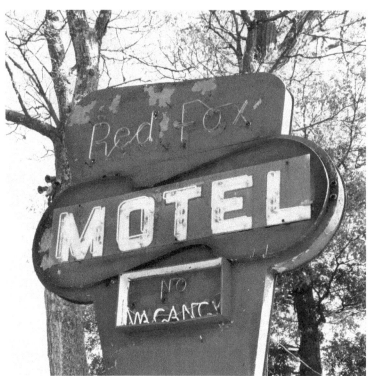

In 1964, about 61,000 motels were open for business in the United States, but their popularity waned after the interstate highway system began to whisk drivers past America's back roads and numbered highways. By 2012, the number of roadside motels had dropped to 16,000.

Some of the remaining mom-and-pop motels found new life when tourists and preservationists rediscovered their quirky charms, but many are in decline and depend heavily on budget-conscious business travelers and weekly rentals to survive. The Red Fox Motel still welcomes guests in Foxboro, Massachusetts, and the River Inn Motel offers hospitality in West Springfield.

Boston mayor John Collins and Massachusetts governor John Volpe both attended the ribbon-cutting ceremony when the Midtown Hotel opened in 1961. Billed as the city's most modern motor hotel at the time, the Midtown's free-standing sign still greets travelers today.

A vintage postcard billed the New Englander Motor Court as the "most modern in the area," with telephones in every room. Located in Malden, Massachusetts, the 1960s-era motel is still open, but the neon sign was torn down in 2017.

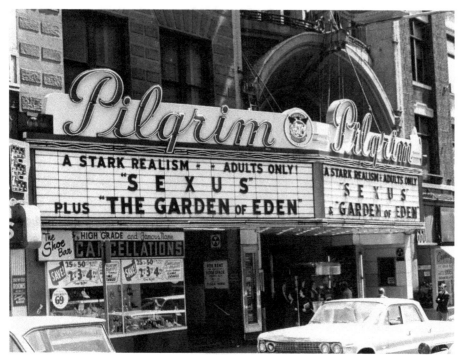

The Pilgrim Theater in Boston, Massachusetts, opened as Gordon's Olympia Theater in 1912. The venue became the Pilgrim after a 1949 update and transitioned from mainstream fare to X-rated films by the 1960s. Briefly a burlesque house in the 1970s, the Pilgrim achieved notoriety when disgraced—and seemingly drunk—Arkansas representative Wilbur Mills joined stripper Fanne Foxe onstage in 1974. The historic theater was demolished in 1996. (Courtesy of City of Boston.)

The Playland Café was the oldest gay bar in Boston, Massachusetts, dating from the late 1930s. Playland and the Pilgrim were both located in the city's adult-entertainment district known as the Combat Zone. The nightspot was known for its piano bar and year-round Christmas lights, but it had a darker element as well. Playland was linked to a notorious murder in the 1990s, and the bar lost its entertainment license in 1998 after police reported evidence of drug dealing. Playland was sold to a real estate developer that year. (Courtesy of City of Boston.)

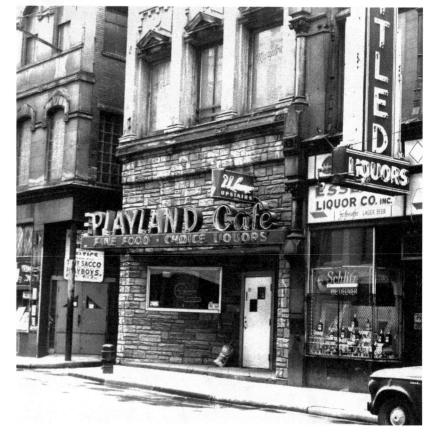

Graham and Norton has been a fixture in Great Barrington, Massachusetts, since 1911 and is the oldest store on Main Street in continuous operation. Current owner John Tracy is a grandson of Charles P. Norton, one of the store's founders.

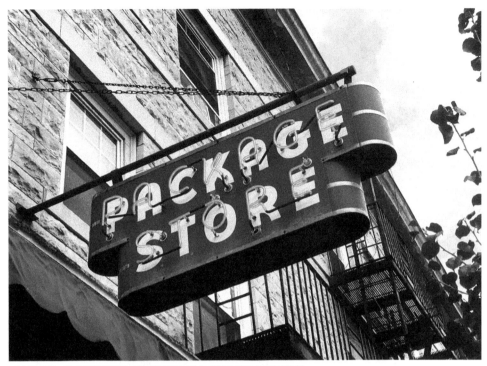

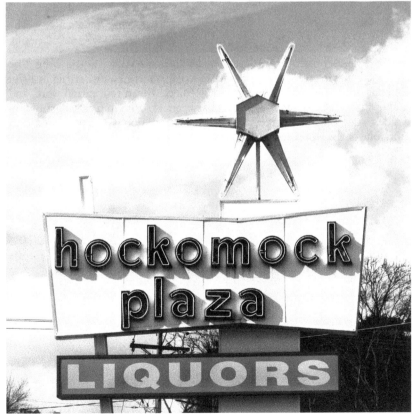

This starburst sign topper, also called a sputnik, is believed to be a Neo-Electra Jr. model from the 1960s. The sign originally revolved, although it has been stationary for years. A developer purchased the West Bridgewater, Massachusetts, property in 2017 and got the Hockomock Plaza sign spinning again early in 2018.

The Cabot Street Theatre opened in Beverly, Massachusetts, in 1920 as a vaudeville house known as the Ware. The theater joined the E.M. Loew's chain in 1960 but transitioned from movies to magic under new ownership in 1976. After the venue closed in 2012, a local consortium purchased the old movie palace, began restoration work, and reopened the historic theater as the Cabot in 2014. Gorham and Norton has been a fixture in Great Barrington, Massachusetts, since 1911 and is the oldest store on Main Street in continuous operation. Current owner John Tracy is a grandson of Charles P. Norton, one of the store's founders.

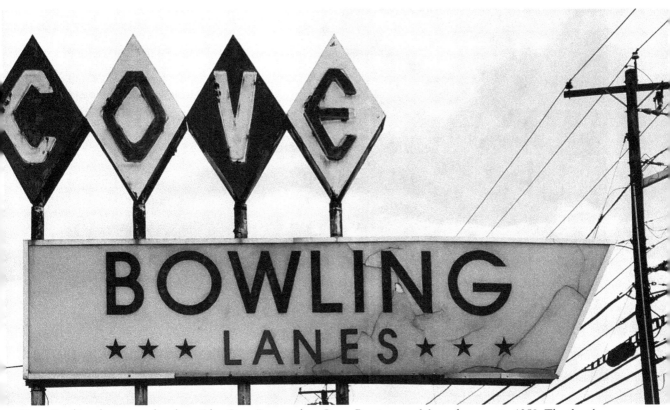

Cove Bowling, known to locals as "the Cove," opened in Great Barrington, Massachusetts, in 1958. The family-owned entertainment center includes 24 tenpin lanes, a miniature golf course, and an arcade.

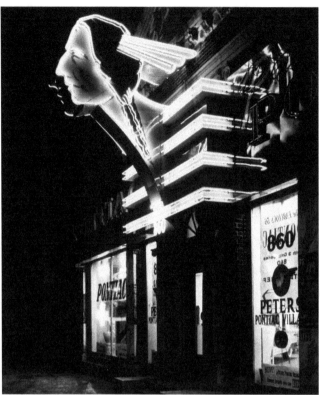

The stretch of Commonwealth Avenue from Kenmore Square to Allston was once known as Boston's Automobile Row. The corridor is now largely owned by Boston University, but it once hosted more than 100 vehicle-related businesses, including this Pontiac dealership. (Courtesy of MIT.)

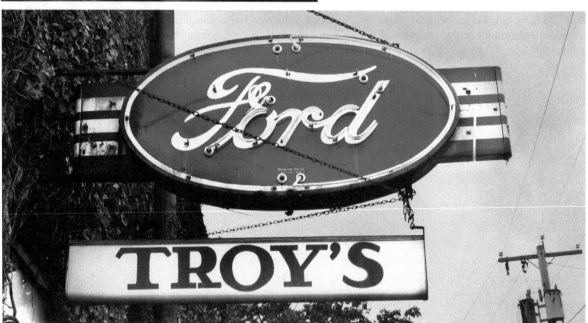

Back in the day, Garrett Troy was a big deal in West Stockbridge, Massachusetts. He was fire chief, deputy sheriff, garage owner, Ford salesman, and more. But he was best known for sponsoring a semiprofessional baseball team talented enough to play exhibition games against major leaguers in the 1930s. Troy's Garage has changed hands over the years, but the Ford sign remains.

A neon hot dog dripping with mustard marks George's Coney Island in Worcester, Massachusetts. Catherine and George Tsagarelis bought the restaurant in 1929 and began to focus on hot dogs. Like Rhode Island hot weiners, these dogs are smothered in yellow mustard, chopped onions, and chili sauce. George commissioned the sign in 1940—his hand is holding the hot dog—and his family still runs the restaurant.

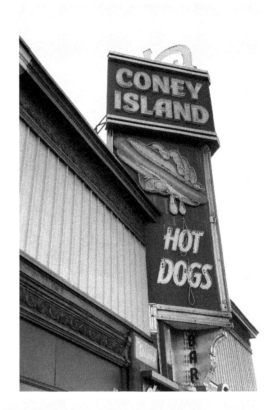

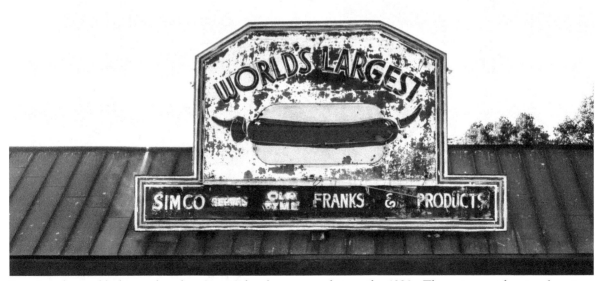

Boasting the world's largest hot dog, Simco's has been around since the 1930s. The restaurant has two locations in Boston, Massachusetts: in Mattapan (where it is known to locals as Simco's on the Bridge) and Roslindale. The Mattapan location has no seating, so it is not uncommon to see people eating in their cars or enjoying their dogs al fresco while sitting along the aforementioned railroad bridge.

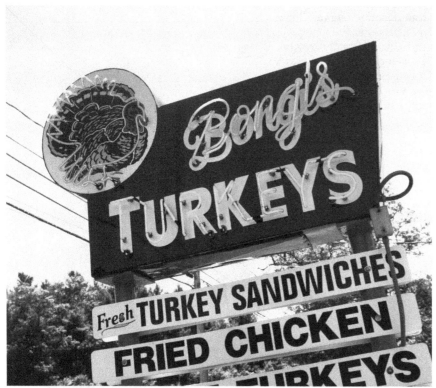

Bongi's Turkey Roost started as a chicken farm when Anna and Tony Bongiorno bought seven acres in Duxbury, Massachusetts, in the 1930s. After World War II, they switched to turkeys, managing one of seven turkey farms along the dirt road that is now Route 53, and set up a retail shop in an old motel cabin. Today, people still line up to buy Thanksgiving turkeys from this fourth-generation family business.

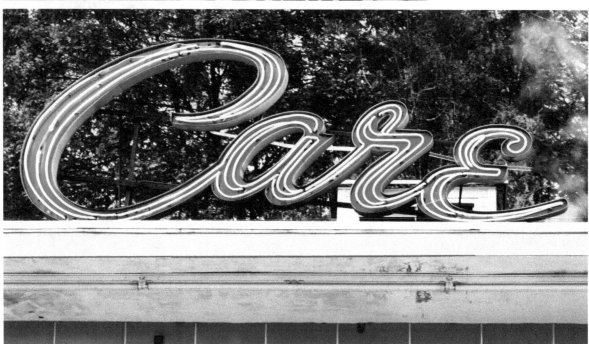

In Chelmsford, Massachusetts, since the 1950s, Care Cleaners has three large roof-mounted neon signs. The "Care" sign takes center stage in a cursive font. Flanking the company name are two block-letter signs reading "Cleaners" and "Laundarama" (not shown here).

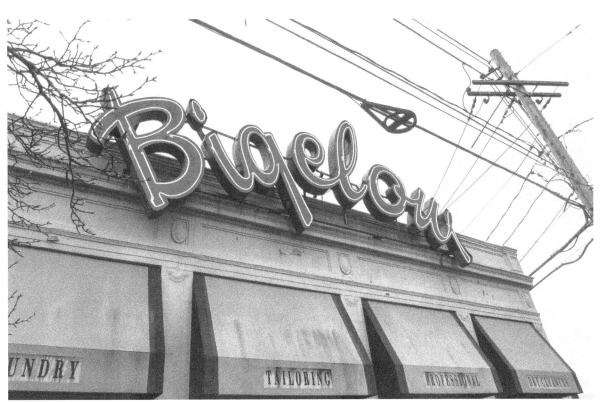

Dry cleaning dates back to Roman times, when a combination of clay, ammonia, and lye was used to remove stains from fabric. Fast forward to the 19th century, when cleaners began using petroleum-based (and highly flammable) solvents like kerosene. A nonflammable alternative, perchloroethylene, or just "perc," was widely adopted in the 1930s and is still in use today. While perc had the great advantage of not catching fire, it has been linked to multiple health issues and many cleaners are phasing it out. In Newton, Massachusetts, Bigelow Cleaners sports two roof-mounted neon signs in a jaunty typeface, one on each side of its prominent corner location. The sign for Queen Cleaners in Waltham features one of those you-know-you're-in-New-England expressions. "Cleansers" can be found on old signs, but unlike widely used phrases like "package store," the term is mostly frozen in neon.

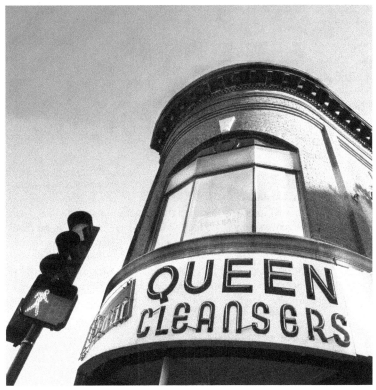

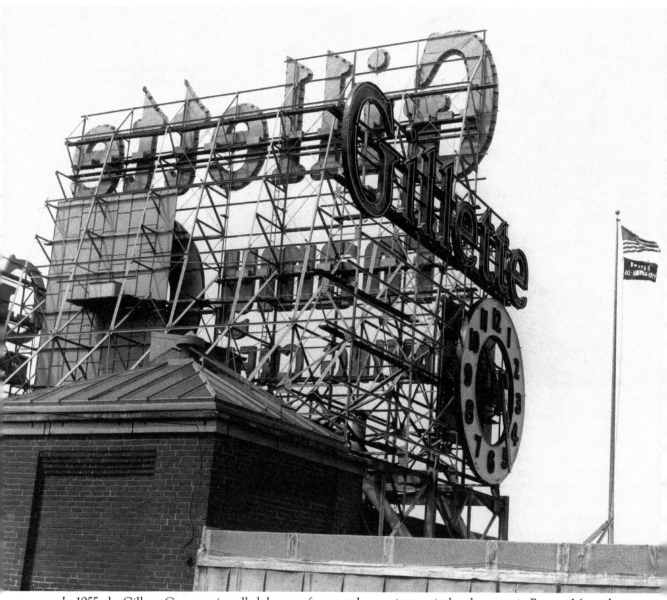

In 1955, the Gillette Company installed three roof-mounted neon signs on its headquarters in Boston, Massachusetts. The main west-facing sign was 60 feet wide by 51 feet tall. Its neon clock was 24 feet in diameter and said to be the largest illuminated clock sign in New England. The two other signs, which also included clocks, were smaller. The letter "G" in the main sign was 18 feet high, and Gillette said that tests proved that the company's name could be read from more than a mile away. According to Gillette's internal newsletter, the *Blade,* neon was expected to "retain its brilliancy under all weather and wind conditions." The clocks were removed in 1969. (Courtesy of Procter & Gamble Corporate Archives–Gillette Collection.)

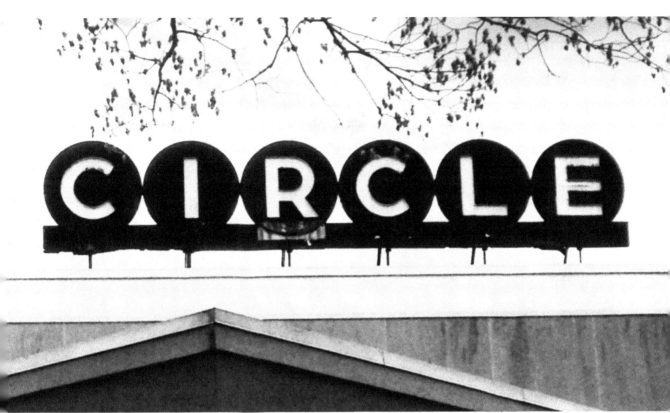

The Circle Theatre opened as a single-screen theater in 1940 on the border between Boston and Brookline in the Cleveland Circle neighborhood. It was designed by Krokyn and Browne, the Boston architects who also were responsible for the West Newton Cinema (Newton, Massachusetts), Oriental Theater (Boston, Massachusetts), and the Grand (Ellsworth, Maine). Redstone Theaters purchased the cinema in 1964 and hired architect William Reisman to redesign the theater in the Brutalist style that was popular at the time. The Circle screened exclusive premieres throughout its history and hosted Hollywood luminaries such as Debbie Reynolds, who came to town in 1966 to promote *The Singing Nun*. The local landmark closed in 2008 and was demolished in 2016 to make way for housing and a hotel. A replica sign with LEDs was incorporated into the new housing complex on the site in 2017.

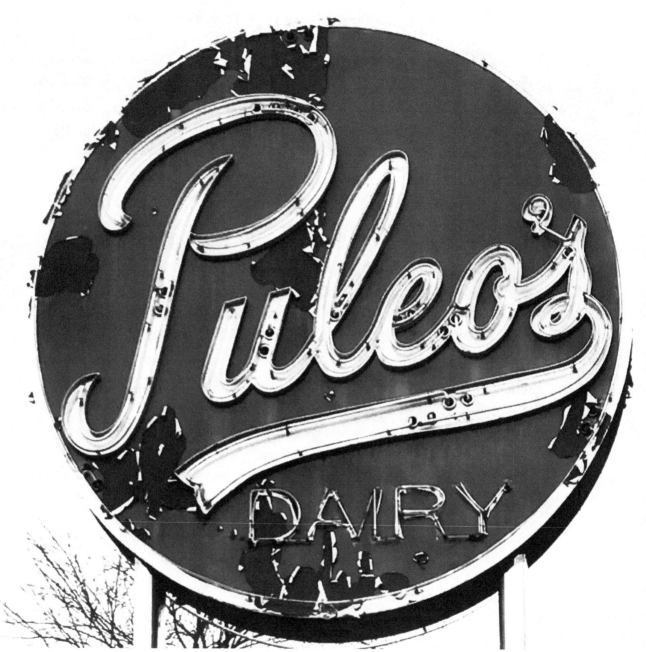

Charles Puleo started Puleo's Dairy in 1928, bottling milk in his garage and making home deliveries in a Model T pickup truck. He opened Puleo's Dairy Bar in 1941, a seasonal ice-cream stand in Salem, Massachusetts, which he ran until his 1984 retirement. Today, his son Charles M. Puleo runs the family business.

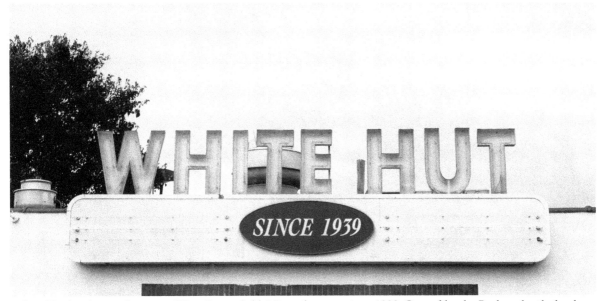

White Hut has been a fixture in West Springfield, Massachusetts, since 1939. Owned by the Barkett family for three generations, the restaurant serves burgers, hot dogs, and French fries to a loyal clientele.

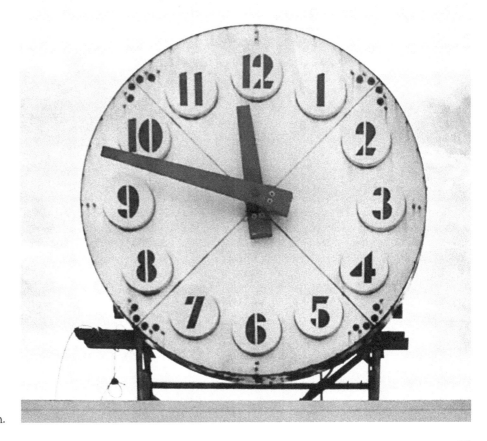

The Sheehan family has owned and operated Red's Towing, Recovery, and Transport since Bernard "Red" Sheehan started the business in 1958. The signature clock, which is about 10 feet wide, dates from 1947 when an Esso station occupied the West Springfield, Massachusetts, location.

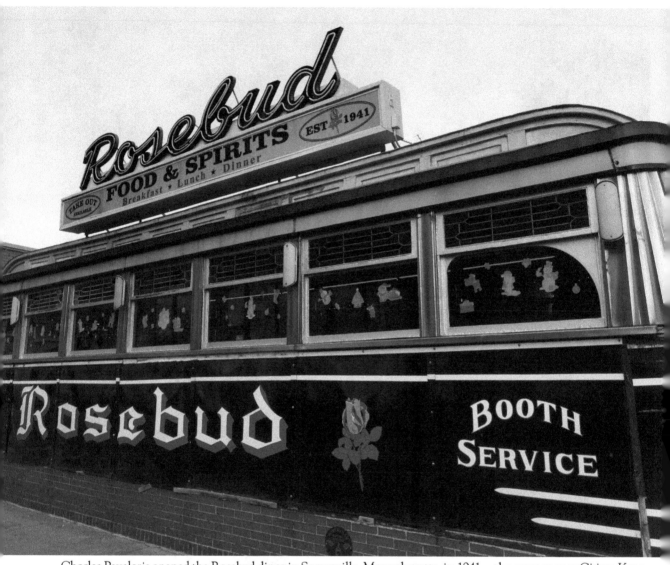

Charles Peveloris opened the Rosebud diner in Somerville, Massachusetts, in 1941—the same year as *Citizen Kane*, the film that inspired its name. Evangelos "Galley" Nichols bought the diner in 1958, and the Rosebud stayed in the Nichols family until a local restaurateur purchased it in 2013. The Rosebud is one of the few surviving Worcester Lunch Cars in the semi-streamliner style. It was placed in the National Register of Historic Places in 1999.

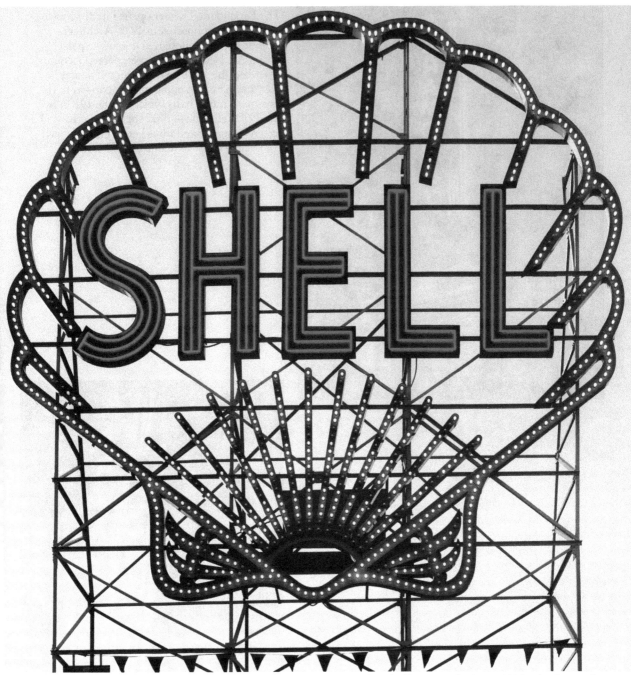

Towering above a working gas station in Cambridge, Massachusetts, the Shell sign was built in 1933 by the Donnelly Electric Manufacturing Company. The 68-foot-tall icon is in the shape of a scallop shell, the familiar trademark of the Shell Oil Company. First located on top of the Shell building in Boston, it was moved to its current location about 10 years later. In 1994, it was placed in the National Register of Historic Places and designated a city landmark in 2009. The sign originally used neon and incandescent lighting to create a sequenced display of moving lights. When the sign fell into disrepair, it was replaced with a faithful LED replica in 2011. The fabricators of the replacement used the original drawings, ensuring that the historic sign continues to stand tall and bright.

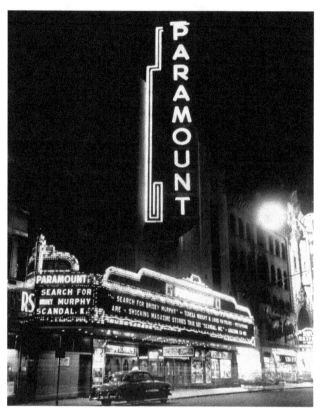

The Paramount Theater opened in downtown Boston, Massachusetts, in 1932. Architect Arthur Bowditch designed the movie palace in the Art Deco style. Contemporary accounts described the 1,500-seat theater as "homey" and "intimate," an apparent comparison to the cavernous music halls typical of the 1920s. By the 1970s, the once-grand theater was reduced to screening X-rated films before closing down completely in 1976. (Courtesy of MIT.)

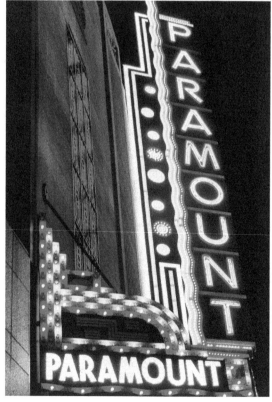

But the story has a happy ending. The Paramount was designated a Boston landmark in 1984. A private developer restored the marquee and facade as part of a community benefits package with the city in 2002. Emerson College acquired the theater and adjacent parcels in 2005 and undertook a multiyear restoration process. The renamed Paramount Center opened in 2010.

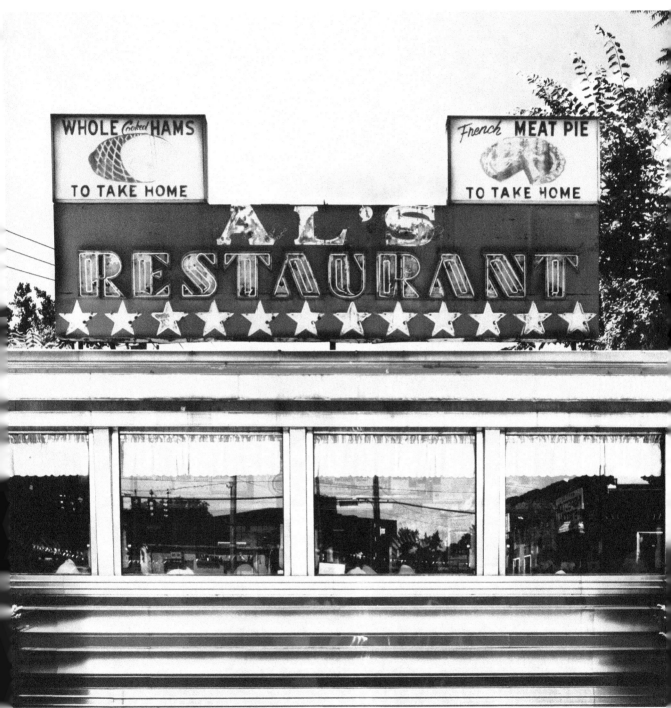

"There is no Al," the menu at Al's Diner reads, "But there once was." In fact, there were two. Al Thibault brought the diner to Chicopee, Massachusetts, in 1958, and Al Rubin purchased the eatery in 1962, changing its name from the White Diner to Al's Restaurant. The Mathews family took over in 1975; they kept Al's name (and the restaurant sign) but began calling the dining spot Al's Diner instead. Al's was built by Master Diners and placed in the National Register of Historic Places in 2000.

The Iantosca brothers opened the Pleasant Café in the Roslindale section of Boston, Massachusetts, in 1939. John Morgan and Jack Lynch bought the restaurant from the original owners in the late 1970s, keeping its recipes along with the retro look and feel of this neighborhood institution.

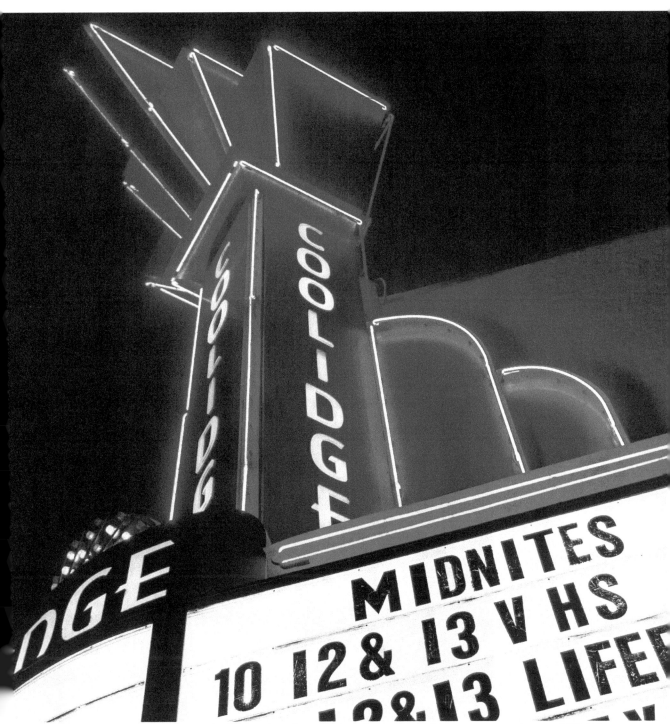

The Coolidge Corner Theatre was built as a church in 1906 and transformed into a movie palace in 1933. The theater was slated for demolition in the 1980s until real estate developer Harold Brown stepped in. He purchased the building in 1989 and leased the Coolidge to a nonprofit, ensuring its survival as a cultural institution in Brookline, Massachusetts. A new neon marquee was installed about a decade later.

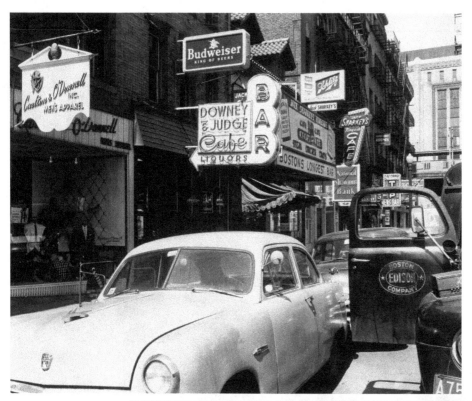

Sitting in the shadow of the Boston Garden, Jack Sharkey's Ringside Bar boasted Boston's longest bar. The counter was 145 feet long, the *Harvard Crimson* wrote in 1934, and "in the smoky haze that pervades the place it is impossible to see from one end to the other." Before becoming a bartender, Sharkey was a world heavyweight boxing champion. (Courtesy of MIT.)

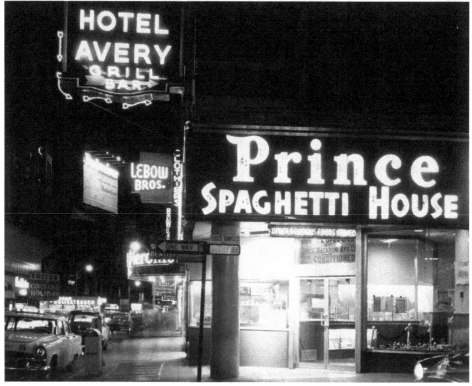

Neon signs enlivened downtown Boston, Massachusetts, in the 1950s. The Hotel Avery once occupied the corner of Washington and Avery Streets in the city's theater district, steps away from the Paramount Theater, and hosted many celebrities in its heyday. (Courtesy of MIT.)

The Lobster Pot is at the tip of Cape Cod in Provincetown, Massachusetts. Ralph and Adeline Medeiros opened the restaurant in 1943, taking over a spot previously occupied by the Colonial Tap. The McNulty family purchased the restaurant in 1979, and members of the extended clan still work in the restaurant today.

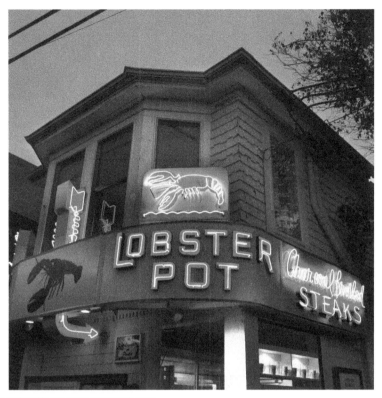

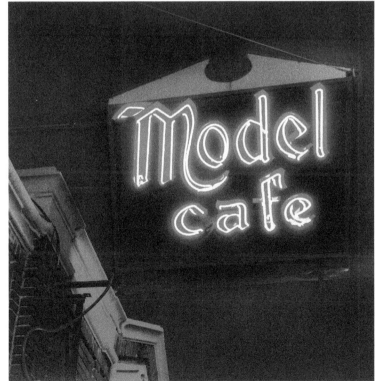

Originally opened as North Beacon Lunch, the Model Café has been in the Anthony family since 1932. Its name reportedly came from a 1940s federal "model" program for revitalizing cities. The Allston, Massachusetts, club, which locals often call the "Mow-Dell," is a popular nightspot among the city's hipster set.

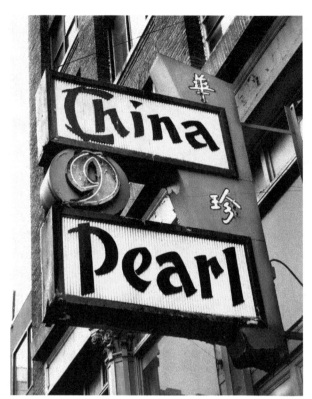

Opened in the 1960s, China Pearl is one of the oldest restaurants in Boston's Chinatown. The Hon Loy Doo restaurant and dance hall previously occupied the site at 9 Tyler Street. Its exterior sign featured an oversized "9" to make it easier for English-speaking patrons (who often could not master Chinese names) to find the restaurant. The China Pearl's sign retains the numeral but at a much smaller scale.

South Pacific was a Polynesian-themed restaurant in Newton, Massachusetts. The mid-century establishment, affectionately called SoPo, served tiki favorites like pupu platters and mai tais for several decades. South Pacific closed its doors in 2012, and the star-studded freestanding sign came down in 2016.

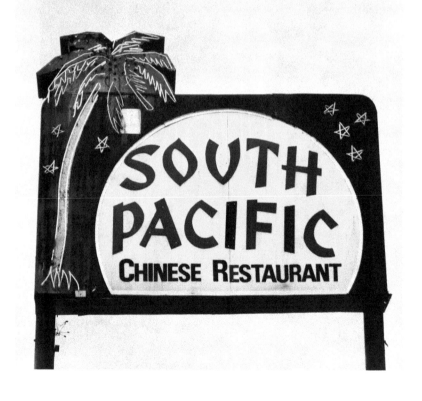

Madeline and William Wong bought the Mandarin House in 1958 and, tapping into the mid-century tiki craze, reinvented the spot as the Kowloon Restaurant and Cocktail Lounge. Over the next 50 years, they transformed Kowloon into a 1,200-seat restaurant, serving everything from pupu platters to sushi. Today, the next generation of the Wong family operates the still-kitschy restaurant and entertainment complex in Saugus, Massachusetts.

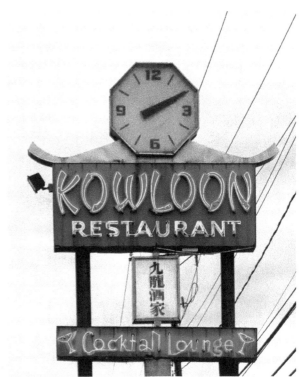

A rooftop neon sign once welcomed diners to a 1950s-era restaurant called China Land in Beverly, Massachusetts. When the owners built another restaurant just down the street, they reworked the sign to read China Jade and installed it at their new location.

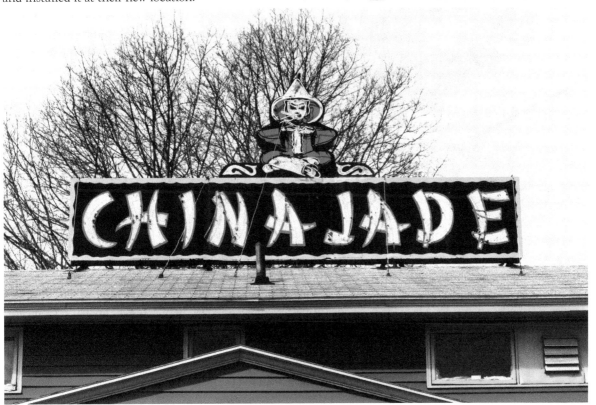

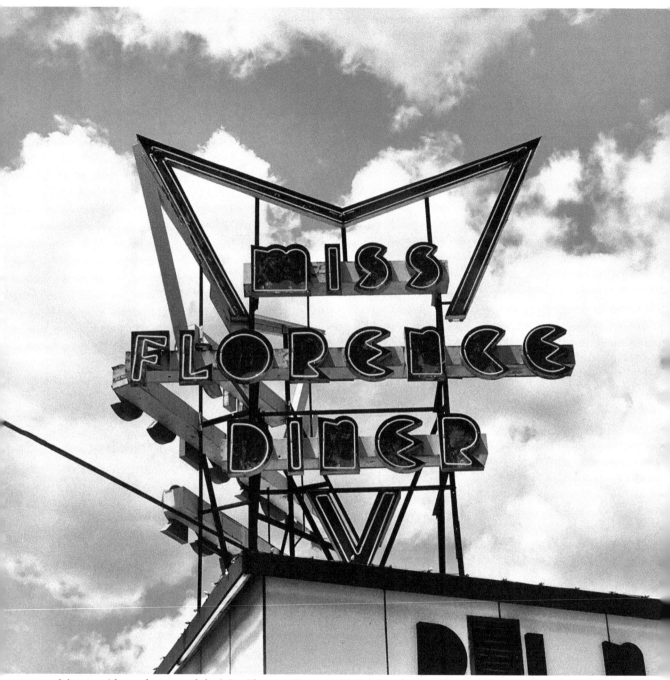

Maurice Alexander opened the Miss Florence Diner in 1941. Manufactured by the Worcester Lunch Car Company (No. 775), "Miss Flo" sits in the Florence section of Northampton, Massachusetts. The Agnoli Sign Company made the roof-mounted neon sign with its distinctive chevron shape and streamlined letters.

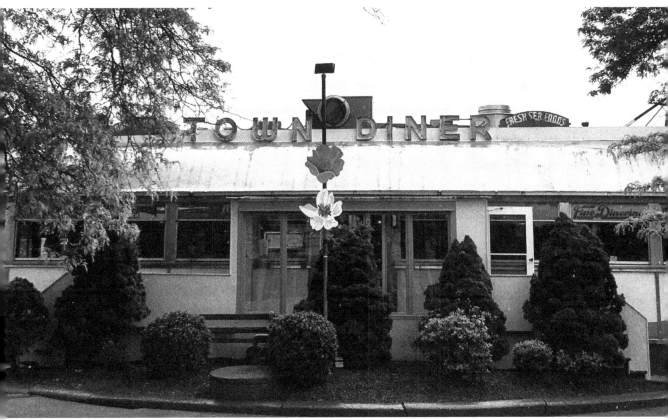

The Town Diner was built in Watertown, Massachusetts, in 1947, replacing an original Worcester Lunch Car. Daryl and Don Levy, who purchased the historic diner in 2000, changed the name to Deluxe Town Diner, restored the interior, and updated the menu. Miss Florence (shown opposite) and the Town Diner are both listed in the National Register of Historic Places.

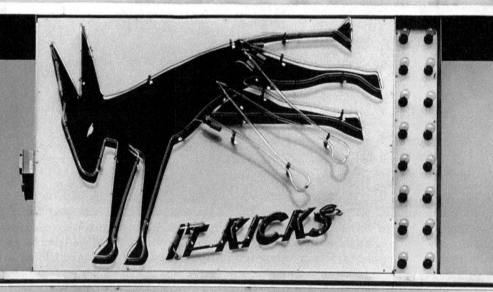

Haffner's started in 1925 with a single filling station in Lawrence, Massachusetts. The company now operates a small chain of gas stations in the Merrimack Valley and is best known for its cheeky donkey logo—seen here on an animated neon sign in Lowell—and the slogan "It Kicks!" The fourth-generation company was sold in 2014 and is now known as Haffner's Energy Group.

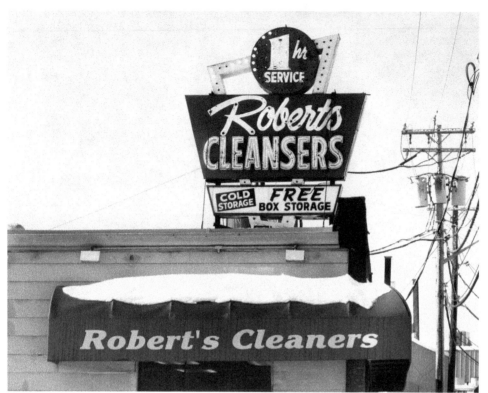

Sam Kaminski and his son Robert started Robert's Cleaners in Lynn, Massachusetts, in 1947. Robert passed the business to his sons Robert Jr. and Paul in 1983, and the brothers continue to run the family enterprise.

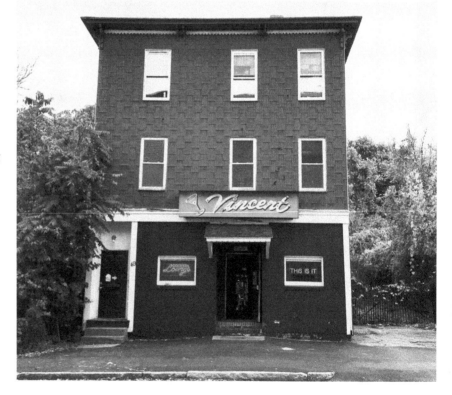

Vincent's is tucked in among three-deckers and industrial buildings in Worcester, Massachusetts. The neighborhood bar is known for its live music, quirky decor that mixes taxidermy with vintage memorabilia, and its meatball sandwich. Even the neon sign has a story. Years before opening the establishment, owner Vincent Hemmeter acquired the sign from Vincent Jewelers and changed the diamond to a martini glass.

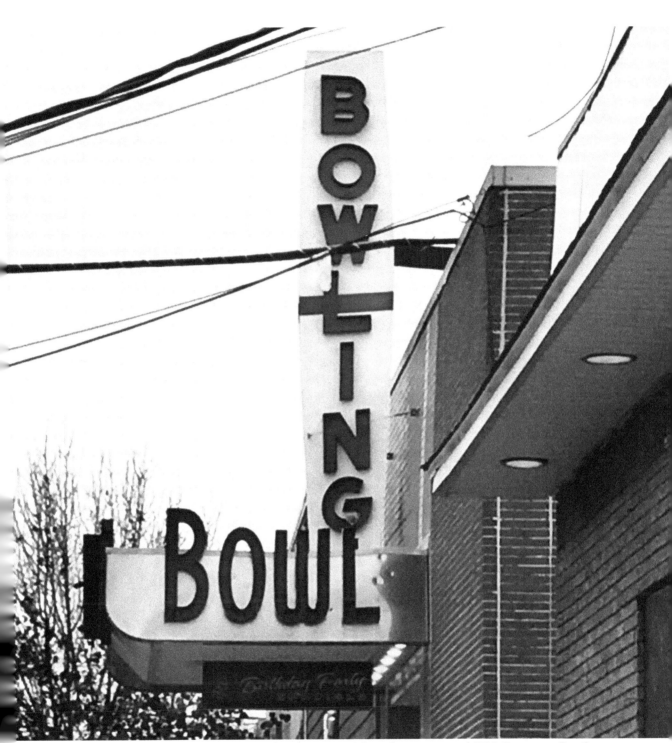

Candlepin bowling is thought to have originated in Worcester, Massachusetts, around 1880. Despite its Bay State origins, the sport is losing popularity in the region. The International Candlepin Bowling Association listed just 30 candlepin centers in Massachusetts in 2017. This venue—the Malden Square Bowladrome, owned by Ryan Family Amusements—closed that year.

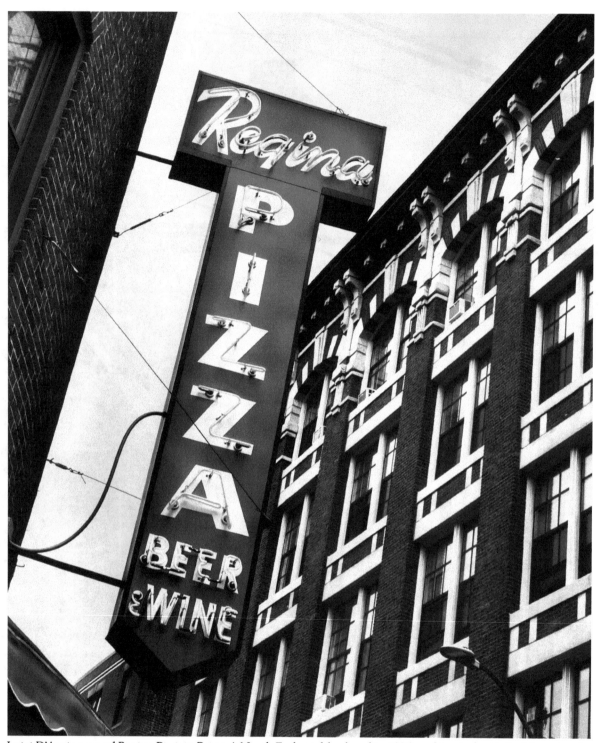

Luigi D'Auria opened Regina Pizza in Boston's North End neighborhood in 1926, making it the city's oldest pizzeria. The Polcari family, which once sold ingredients to Regina's from its grocery store, purchased the pizzeria and continues to operate it today. The restaurant still uses its original brick oven, built in 1888, to fire its pizzas.

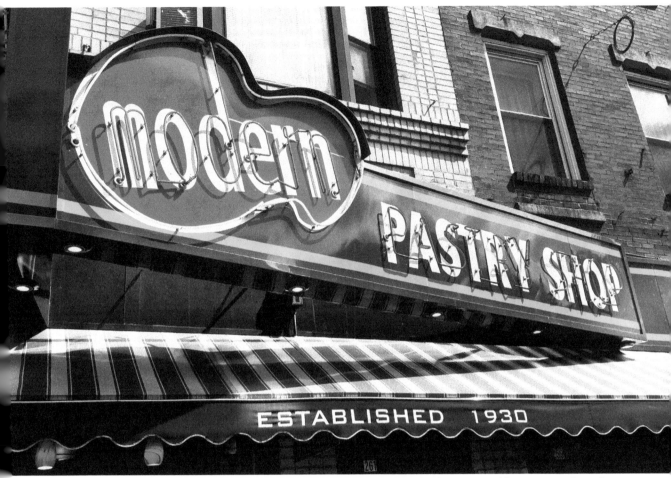

Modern Pastry opened in 1930 in the North End section of Boston, Massachusetts, and has remained in the Picariello family for three generations. The bakery offers a range of old-world confections but may be known best for its custom-filled cannoli.

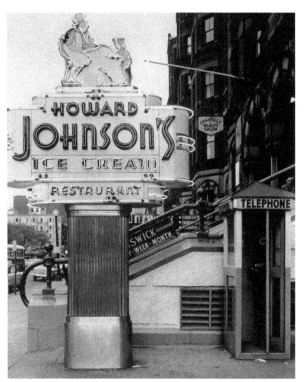

Howard Deering Johnson opened his first soda fountain in Quincy, Massachusetts, in 1925. From this modest beginning, Howard Johnson's became the largest restaurant chain in America in the 1960s and 1970s, famed for its orange roofs and 28 flavors of ice cream. The company modeled its logo on the Simple Simon nursery rhyme, seen here in Boston in the 1950s. (Courtesy of MIT.)

In 1946, Florence Connolly bought a business in South Hamilton, Massachusetts, to run with her husband, Henry. Connolly's Pharmacy included a soda fountain, and the Connollys' son George worked as a soda jerk (although he preferred the term "fountain engineer"). Henry Connolly retired in 1973, and former fountain engineer George took over the pharmacy. His son Chris followed suit in 1999.

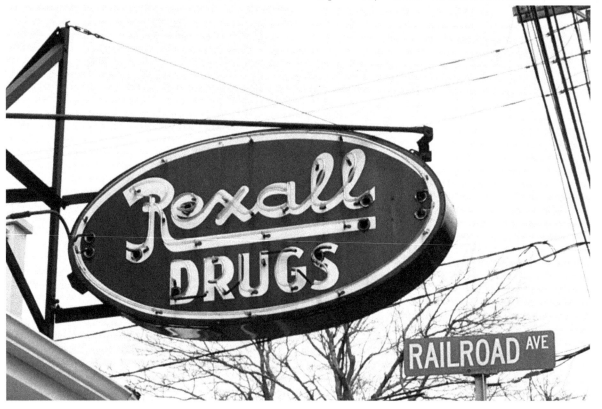

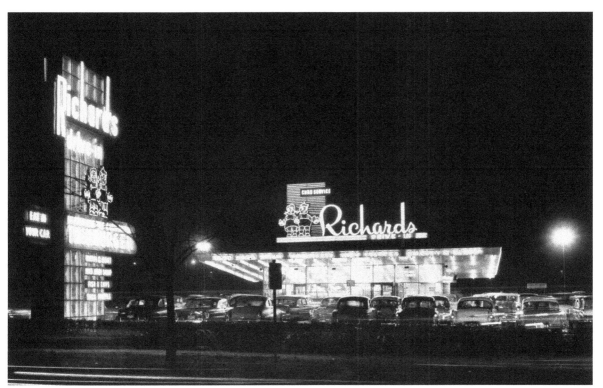

In the late 1950s, the General Cinema Corporation began to diversify beyond the movie business with a chain of restaurants called Richard's Drive-Ins and a string of coffee shops known as Amy Joe's Pancake Houses. Richard's is shown here on Memorial Drive in Cambridge, Massachusetts. (Courtesy of MIT.)

Harry Cohen began selling hot pastrami sandwiches from a roadside shack in 1946. A former painter, he lined up the slices of bread and applied the mustard with a paintbrush. The menu expanded over the years, and Harry's Restaurant moved to Westborough, Massachusetts, in 1969. To better attract customers on busy Route 9, Harry's added a neon arrow from a drive-in theater. Today, Harry's son Jon Cohen owns the restaurant.

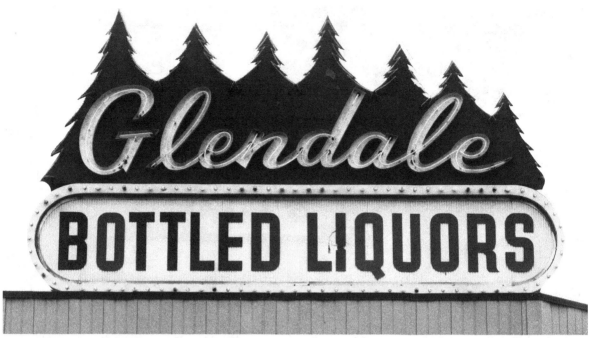

The sign for Glendale Bottled Liquors tells a story. Each evergreen tree represents one of the seven children in the Williams family, who owned the store in Waltham, Massachusetts. The sign dates from 1954 but came down in 2015 after the store changed ownership. The city rescued the sign and plans to find a new home for it.

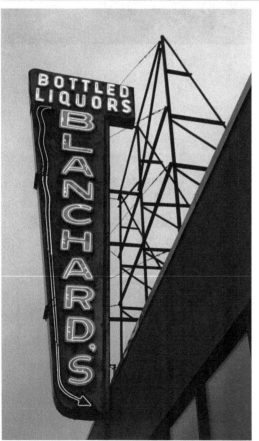

In 1938, John Corey purchased Blanchards, which was then a 100-year-old liquor retailer based in Boston. The business eventually expanded to seven locations, and a third generation of the Corey family owns and operates the liquor stores today. A neon sign still illuminates the chain's flagship location in the Boston neighborhood of Allston, Massachusetts.

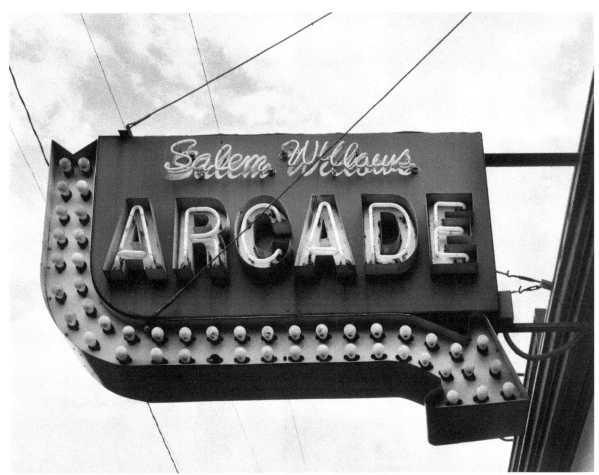

Salem Willows Park was established in 1858, named for the white willow trees planted a half-century earlier for patients convalescing at a local smallpox hospital. Jazz legends such as Duke Ellington and Louis Armstrong played at the park in the 1920s, entertaining audiences at this waterfront locale. Today, Salem Willows includes a mix of classic boardwalk eateries, kiddie rides, and two arcades with a mix of retro and modern games.

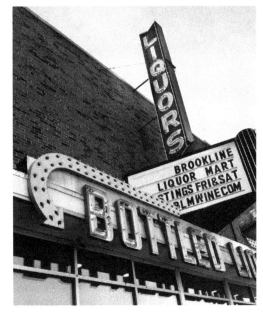

Brookline Liquor Mart is a fourth-generation family business with two locations in the Boston, Massachusetts, area. Two large neon and incandescent signs were removed from the storefront in Boston's Allston neighborhood when the company relocated in 2017 and sold its building.

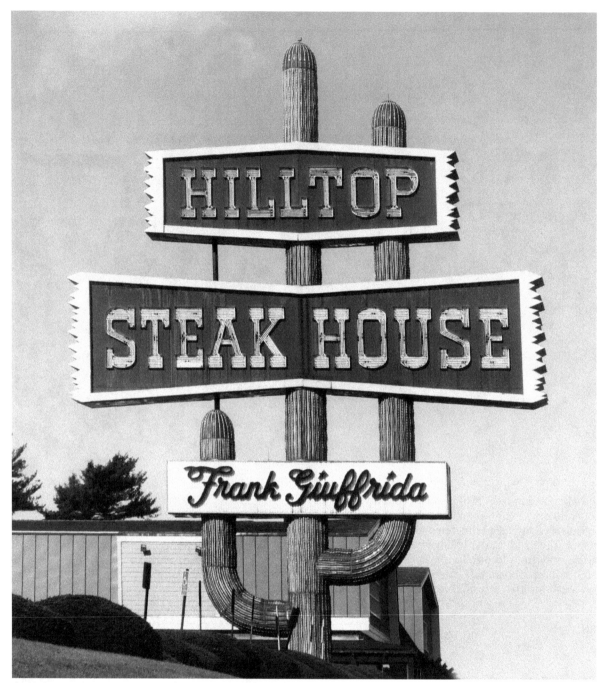

A 68-foot neon cactus attracted customers to the Hilltop Steak House, which opened in 1961 on US Route 1 in Saugus, Massachusetts. The landmark succulent contained 210 fluorescent lightbulbs and nearly half a mile of neon tubing. Six flatbed trailers were needed to haul the sign elements to the site, and construction workers had to blast a hole that was eight feet deep, 28 feet long, and 15 feet wide. The sign took five days to assemble and cost more than $68,000. It was designed by Charles Magliozzi, who told the *Boston Globe* in 1990 that the cactus was an afterthought. "We tried many ideas—a Western motif, cowboys, and cattle—before coming to the cactus," he said. The restaurant closed in 2013, but the sign was saved to be incorporated into future development on the site.

Two
RHODE ISLAND

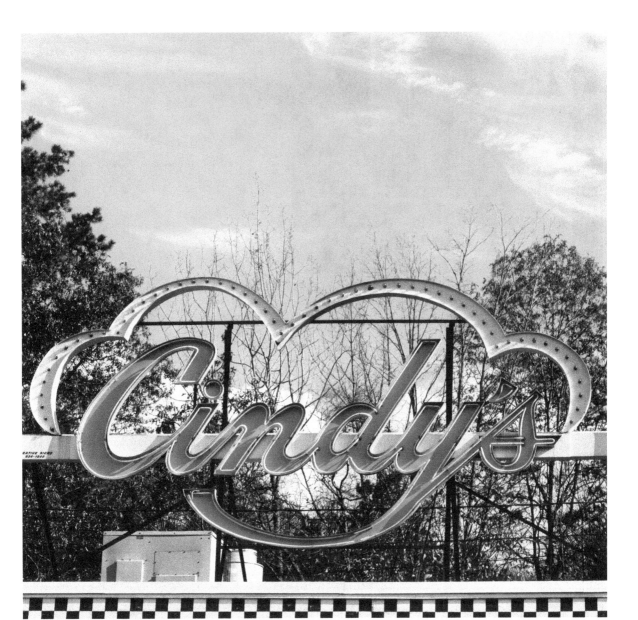

Cindy's Diner and Restaurant in North Scituate, Rhode Island, dates from the 1950s and was named after the original owner's daughter. Edna Sauriol purchased the eatery about 30 years ago, and today, her five daughters own and operate this family-run enterprise.

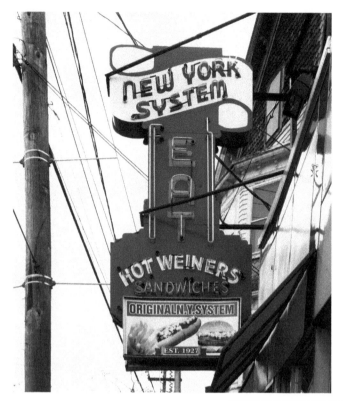

Hot weiners are a Rhode Island specialty, along with coffee milk and Del's Frozen Lemonade. The weiners are typically small hot dogs made with veal and pork, served in a steamed bun, and topped with celery salt, yellow mustard, chopped onions, and meat sauce. (Customers know this combination as "all the way.") These early fast-food joints originated within the state's Greek immigrant community; the "New York System" moniker was an attempt to give the local offerings some Empire State pizzazz.

Two of the best known "Systems" are in Providence, with nearly identical signs. Augustus Pappas started the first New York System in 1927 (which later appended "Original" to its name). The establishment stayed in the family until 2013; now the Toprak family owns it. Anthony Stavrianakos and his son opened the Olneyville New York System in 1946 (right). Today, a fourth generation of the family (now called Stevens) runs the grill.

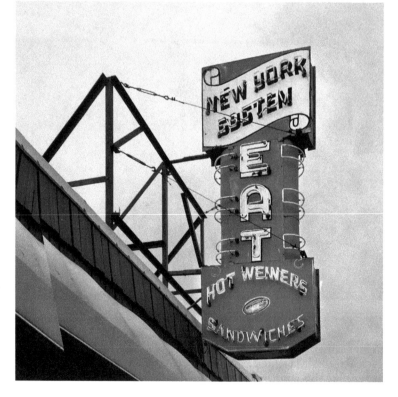

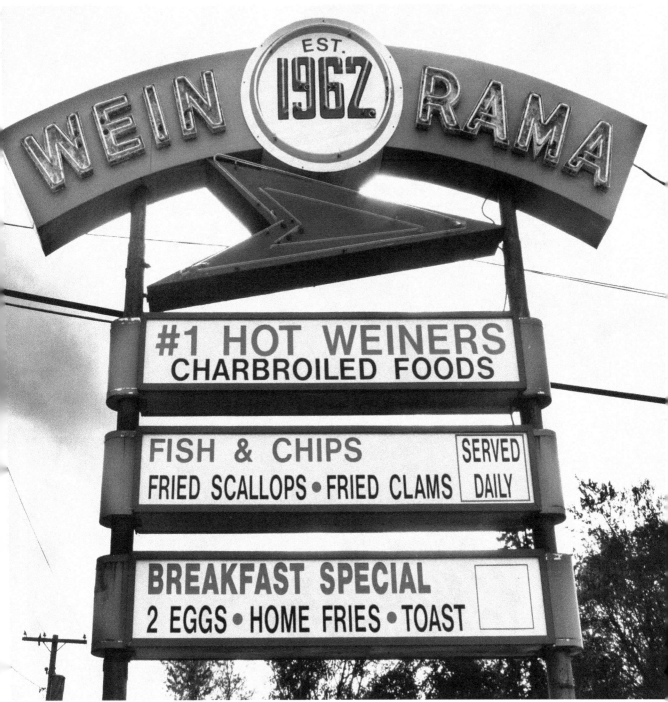

Part of the Rhode Island hot weiner experience is ordering half a dozen or more "up d'ahm." (That would be "up the arm" to non-Rhodians.) Cooks line up the buns along their arm (sometimes to the shoulder), add the weiners, and slather on the traditional toppings. Greek immigrant Michael Sotirakos opened Wein-O-Rama in Cranston in 1962, drawing inspiration from the mid-century "o-rama" naming craze, and today, his sons Ernie and George run the establishment.

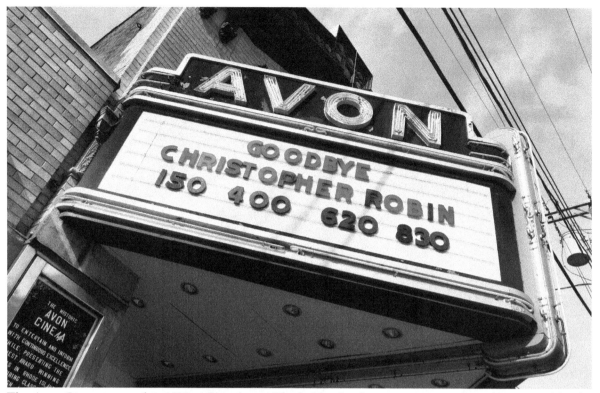

The Avon Cinema opened in 1938 in Providence, Rhode Island, taking over a space originally occupied by the Toy Theater. The theater has long specialized in independent and foreign films, except for a few years in the 1940s when it operated as a second-run house. It survives today as a single-screen oasis in a multiplex world.

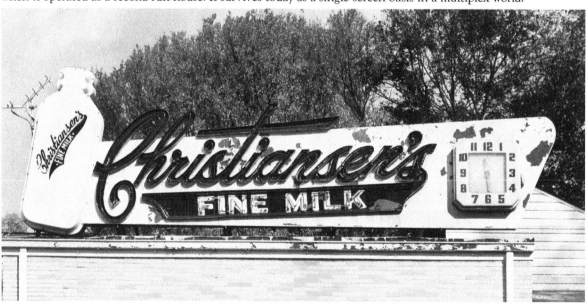

Alfred Christiansen started a small dairy farm in the 1920s and began delivering milk and eggs from a horse-drawn wagon. Today, Christiansen's Dairy is a third-generation family-owned business in North Providence, Rhode Island, that still delivers milk to its customers' homes in glass bottles.

The Greenwich Hotel and Lounge was constructed in 1896, replacing a building that housed the colonial-era Arnold Tavern and later the Updike Inn. Anthony Joseph bought the hotel in 1971, and his daughter Joann Joseph took over the East Greenwich, Rhode Island, establishment in 1989. She can often be found playing the bass guitar while bartending.

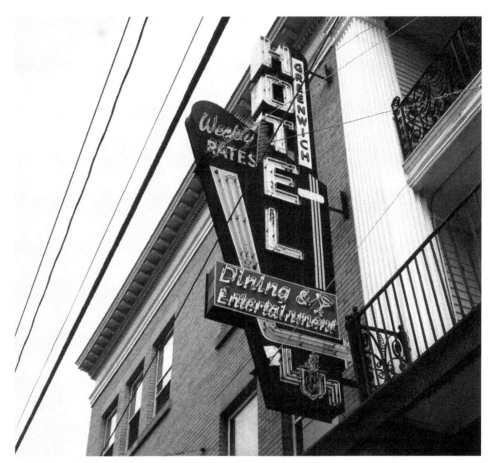

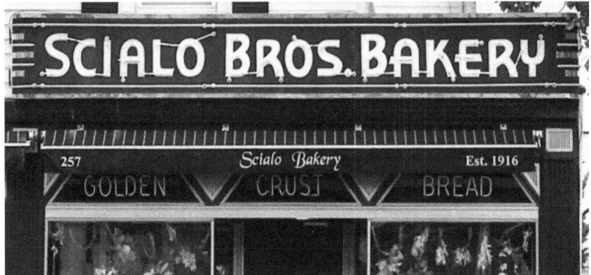

Luigi Scialo and his brother arrived in Providence, Rhode Island, from Italy in 1916 and established a bakery in the city's Federal Hill neighborhood. Luigi ran the Scialo Brothers Bakery with his family until his death in 1993, and today, his daughters Lois Ellis and Carol Gaeta continue the tradition.

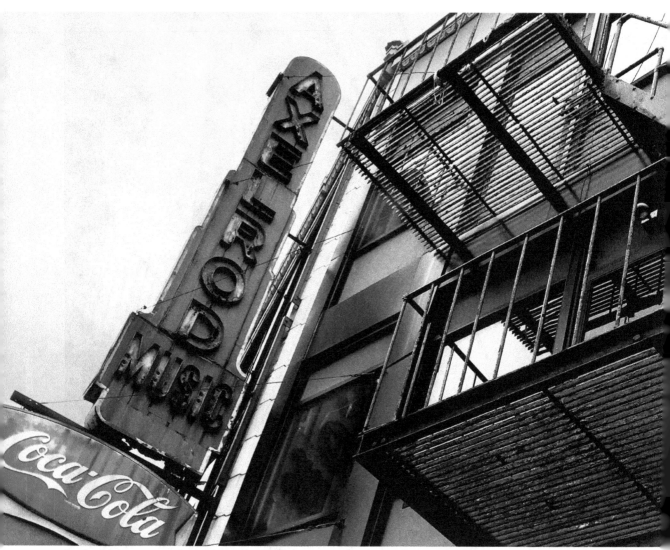

Axelrod Music opened in 1910 in the Downcity section of Providence, Rhode Island. Generations of musicians purchased sheet music and instruments from the shop, fondly remembered for its old-school charm and creaky wooden floors. The business moved from Providence to Johnston, leaving its neon sign behind, and closed in 2009.

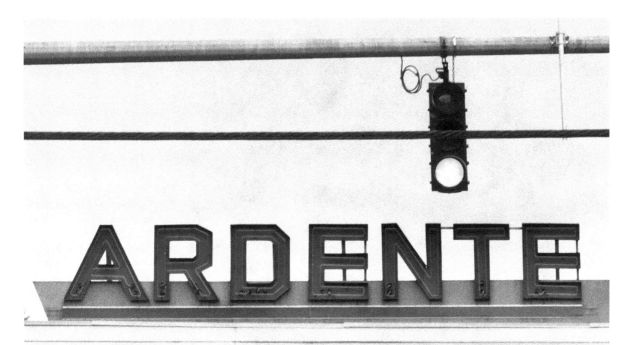

Ardente Supply Company was founded in 1946 in Providence, Rhode Island. Now known as WaterSpot, the plumbing and heating supply company has been in the Ardente family for three generations.

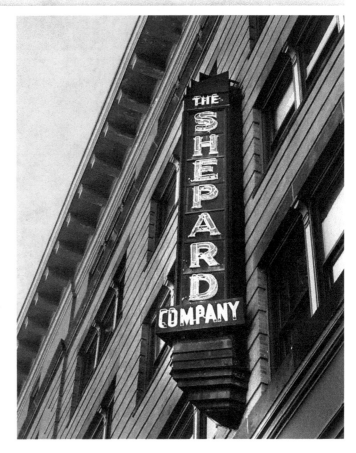

Shepard and Company opened for business in downtown Providence, Rhode Island, in 1880 in a three-story building. Founder John Shepard Jr. had a grander vision for his store, however, and by 1903, Shepard's occupied what was once a three-block area. The department store contributed to the economic growth of the city, and shopping at Shepard's was a tradition for generations of Rhode Islanders. At one point, Shepard's was the largest department store in New England, but the retailer closed its doors in 1974. The State of Rhode Island owns the landmark building now, which currently houses state offices and campuses for the University of Rhode Island and the Community College of Rhode Island.

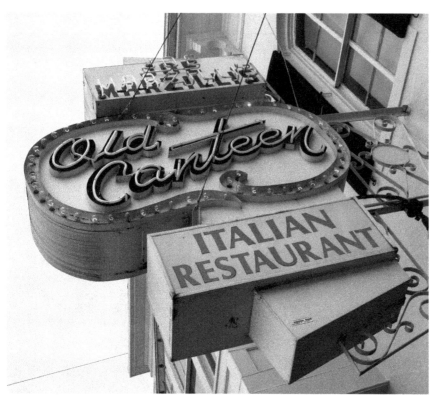

In 1956, Joe Marzilli opened the Old Canteen restaurant on Federal Hill in Providence. The restaurant, with its signature pink walls, was a favorite dining spot for local politicians, including former Providence mayor and convicted felon Vincent A. "Buddy" Cianci Jr. Marzilli died in 2007, and his son Sal took over what is now the oldest family-owned Italian restaurant in Rhode Island.

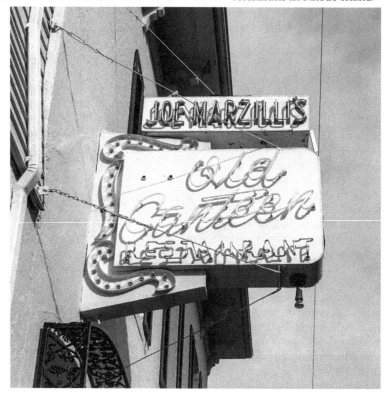

In 1926, Rhode Island industrialist Arthur Darman built the Stadium Theatre in Woonsocket. The Stadium presented vaudeville acts and Hollywood films, hosting stars such as Al Jolson and Will Rogers. But changing tastes in entertainment forced the theater to close its doors in 1985. Efforts to save and restore the theater began in 1991, however, and the Stadium began welcoming patrons again in 2001.

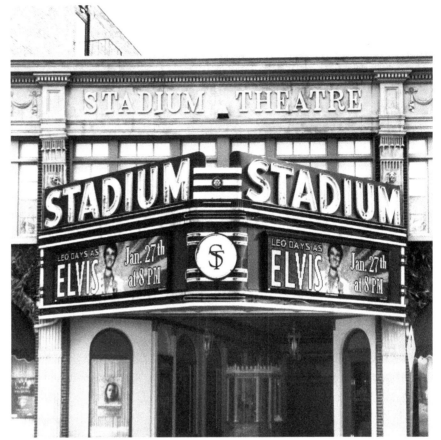

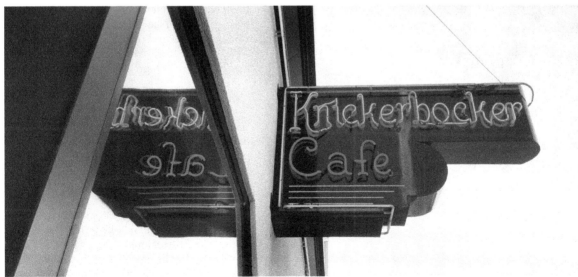

Dating from 1933, the Knickerbocker Café was named after the Knickerbocker Express train that passed through Westerly, Rhode Island, on its runs between Boston and New York. The club has hosted blues musicians from Big Joe Turner to Stevie Ray Vaughan, and Roomful of Blues once called the "Knick" home. The café is now the nonprofit Knickerbocker Music Center in partnership with the Rhode Island Philharmonic Orchestra and Music School.

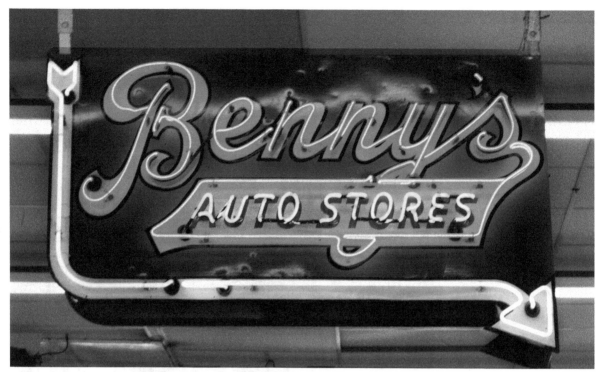

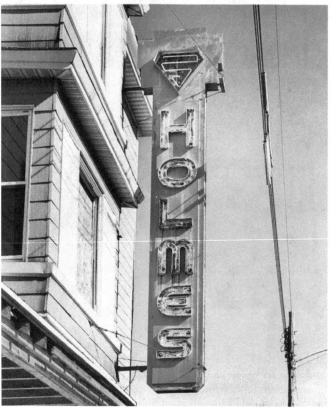

Benjamin Bromberg opened a small automotive shop in Providence, Rhode Island, in 1924. Bromberg and his wife, Flora, added sales outlets as their business succeeded, and Benny's grew into a 32-store retail chain in southeastern New England that sold everything from ice skates to clamming rakes. Bromberg's son and then his grandchildren took over the store, which remained in the family until the chain closed in 2017.

West Warwick, Rhode Island, was incorporated in 1913, splitting from the larger town of Warwick. The new municipality was home to the Pawtuxet Valley's textile mills, and a series of mill villages became the focus of the region's economic and social activities. The Arctic village was the commercial hub for the town and all of central Rhode Island until the regional shopping malls began to draw customers away in the 1960s. The sign for Holmes Jewelers likely dates from the 1940s. The family-owned business eventually moved out of West Warwick, and the building was demolished in 2018. The sign was reportedly saved for potential reuse.

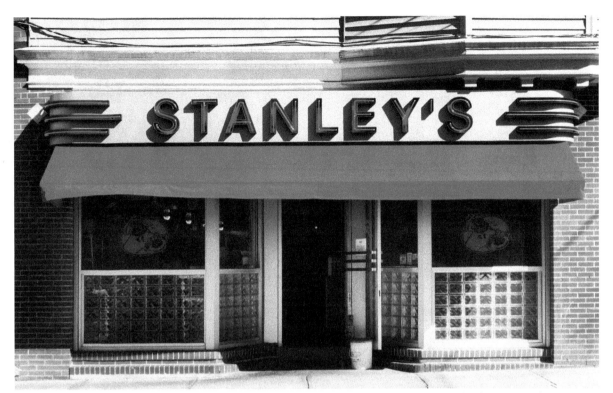

In 1932, Polish immigrant Stanley Kryla opened a restaurant in Central Falls, Rhode Island. His "Stanley Burgers" were known throughout the region, and Stanley's Famous Hamburgers became a Blackstone Valley institution. Former manager Louie Augusta purchased the business in 2016.

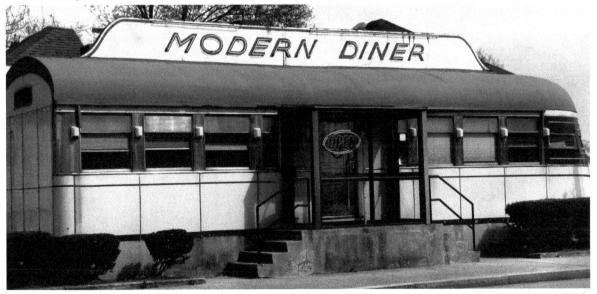

With a design inspired by the streamlined locomotives of the era, the Modern Diner opened in Pawtucket, Rhode Island, in 1940. One of only two Sterling Streamliner diners known to be still in operation (the other is the Salem Diner in Massachusetts), the Modern Diner was placed in the National Register of Historic Places in 1978. It was the first diner to join the list.

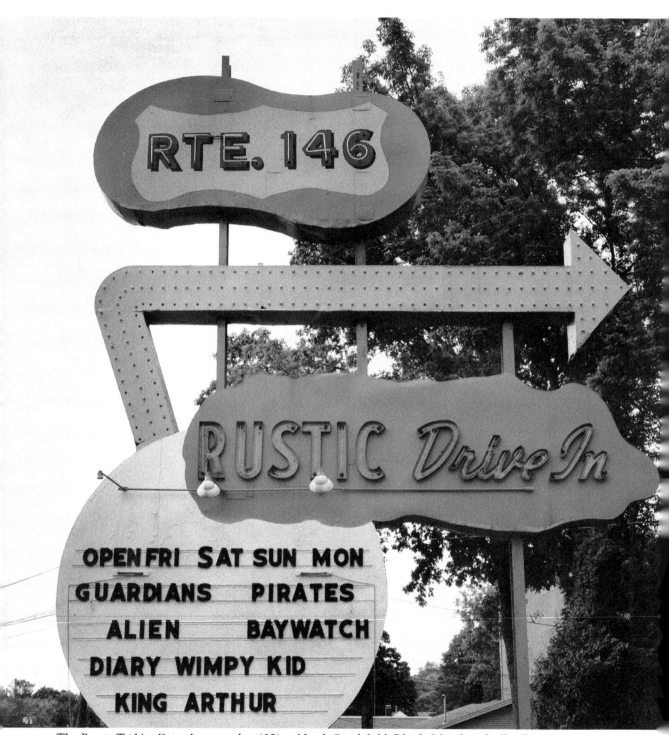

The Rustic Tri-Vue Drive-In opened in 1951 in North Smithfield, Rhode Island, and offered moviegoers an escape from the summer heat. In the 1970s, the Rustic had trouble competing with air-conditioned indoor theaters, however, and began showing adult films to survive. New ownership in the 1980s turned the theater around, and today, the Rustic is the last drive-in operating in Rhode Island.

Three

CONNECTICUT

Zip's is a family-run diner in Dayville, Connecticut. Named after its original owner Henry "Zip" Zehrer, a retired Connecticut state trooper, the diner moved to its current location in 1954. Conrad and Olive Jodoin purchased the diner in 1960, and Zip's is currently in its third generation of family ownership. The diner has been featured in the *Zippy* comic strip, which is penned by Bill Griffith.

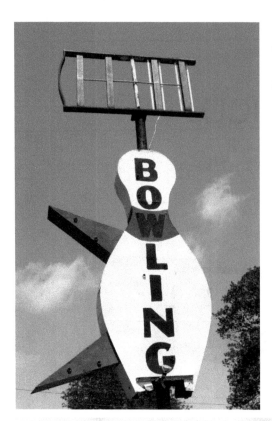

Hi-Way Bowling, long closed, reportedly offered 24 lanes of duckpin bowling in Plainfield, Connecticut. Duckpins look like squat tenpins, the ball is about the size of a grapefruit, and players are allowed three rolls per frame. The sport was especially popular in Connecticut, Rhode Island, and Maryland but is slowly disappearing.

Some attribute the decline to a technology gap. In 1953, Ken Sherman invented an automatic pin-setting machine for duckpin bowling. When his company shut down, however, he refused to sell his patent to industry leader Brunswick Equipment. Without a company to manufacture new pin-setters, duckpin alleys were forced to rely on antiquated equipment and salvaged parts. About 40 duckpin alleys were open across the United States in 2016, down from nearly 450 in 1963.

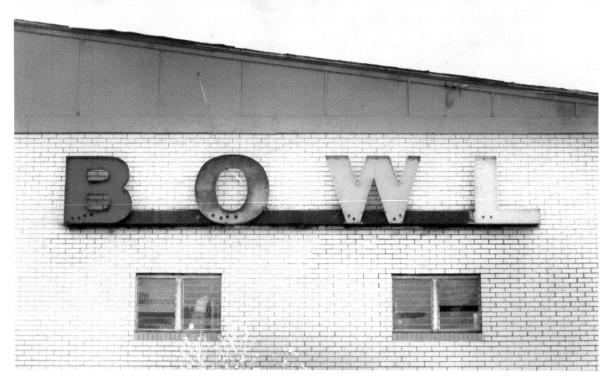

The popularity of motels—the word comes from a contraction of "motor hotel"—exploded in the postwar years as Americans took to the roads in unprecedented numbers. Often family owned, many of these roadside rest stops used neon signs and creative architecture to attract weary travelers. The Maple Motel, on the Berlin Turnpike in Newington, Connecticut, boasts a cheerful neon sign topped by a mid-century starburst.

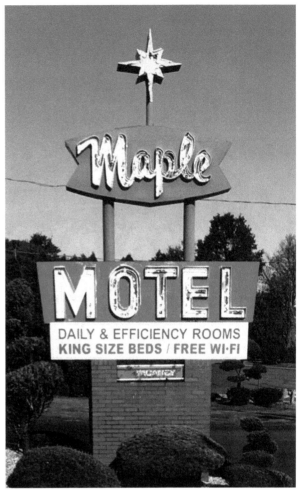

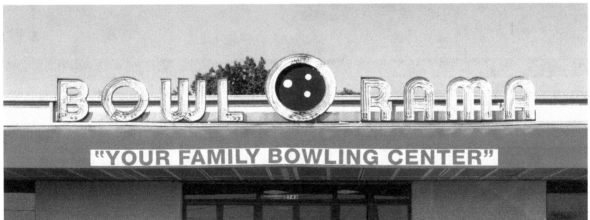

In 1959, police officer Frederick H. Callahan Jr. and his wife, Loretta, decided to build a bowling alley on their farmland in Newington, Connecticut. Frederick, who was known as Bud, could often be found working on the equipment, while Loretta staffed the front desk. More than 50 years later, a third generation of Callahans is running Bowl-O-Rama.

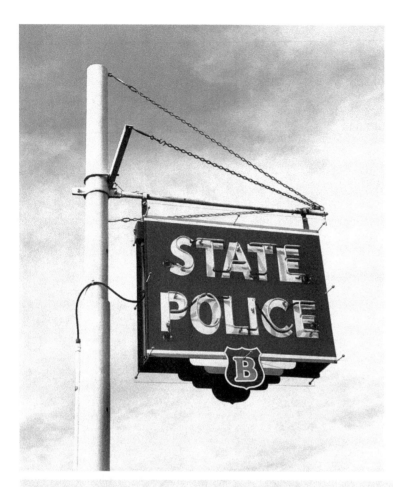

Lt. William Baldwin saved the signs outside the Connecticut State Police Troop B building twice. For decades, a pair of neon signs hung outside the North Canaan structure. In 1996, then-sergeant Baldwin found one in a scrap heap and led a community effort to restore both signs. In 2015, when Baldwin was back at Troop B, the signs were showing their age. He worked with Ghi Sign, which solicited community contributions to complete the work.

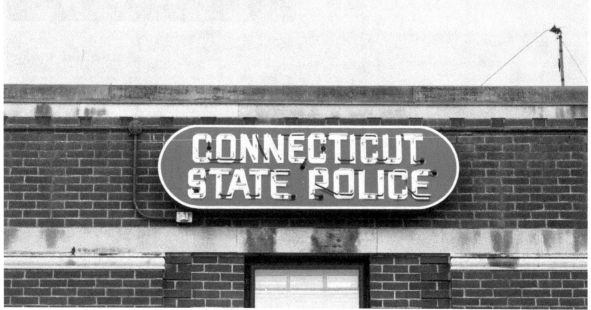

The Shoreline Motel in Milford, Connecticut, has two old neon signs—one mounted on the roof and one freestanding—to capture the attention of passing drivers on US Route 1. A vintage postcard boasts, "Be at home away from home," and promises guests a television lounge and automatic heat.

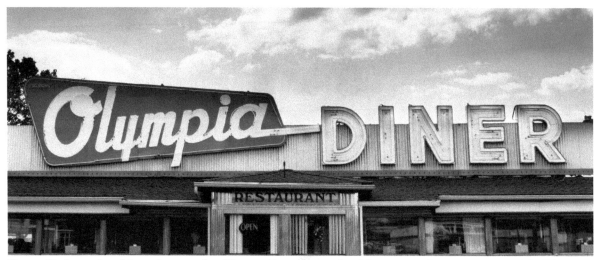

Originally located in Massachusetts, the Olympia Diner opened in Newington, Connecticut, in 1954. The Jerry O'Mahony model is said to be the longest stainless-steel diner in the country, and it was trucked to its present location in three sections. Michael Kritikos was the original owner of the Olympia, and Emmanuel "Manny" Gavrilis bought the business in 1974. Today, his sons Steve and Tasos run the diner.

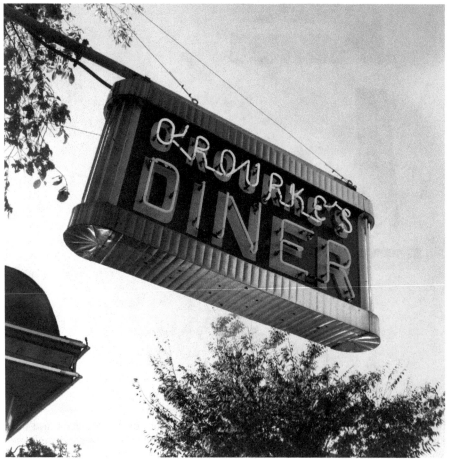

O'Rourke's Diner is part of the Main Street Historic District in Middletown, Connecticut. John J. O'Rourke purchased an old wooden diner in 1941 and replaced it with a gleaming Mountain View model five years later. When the diner sustained major damage from a fire in 2006, community residents raised enough funds to rebuild the local landmark.

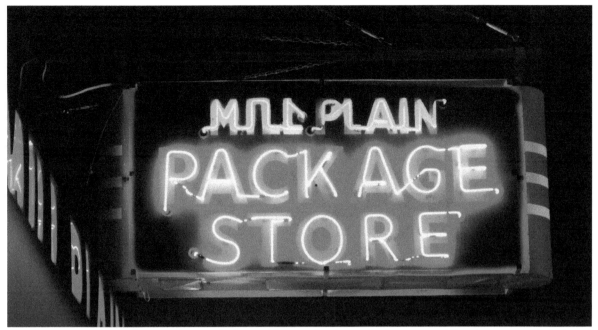

A package store—often shortened to "packie"—is a New England term for liquor store. The phrase is widely believed to come from post-Prohibition laws that required stores to wrap up, or package, bottles of liquor and wine after they were purchased. Here are two still-working signs from Connecticut package stores, both about 60 years old. Mill Plain Package Store is in Danbury, and Old Colony Package Store is in Old Saybrook.

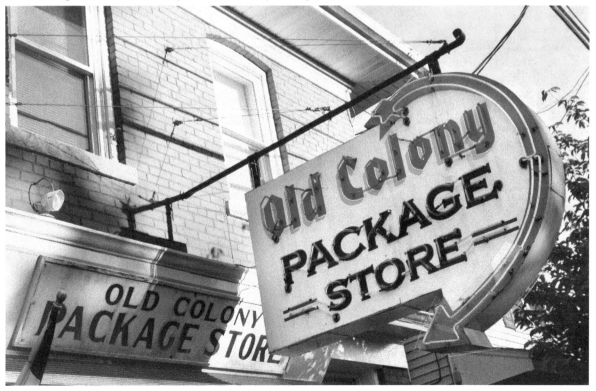

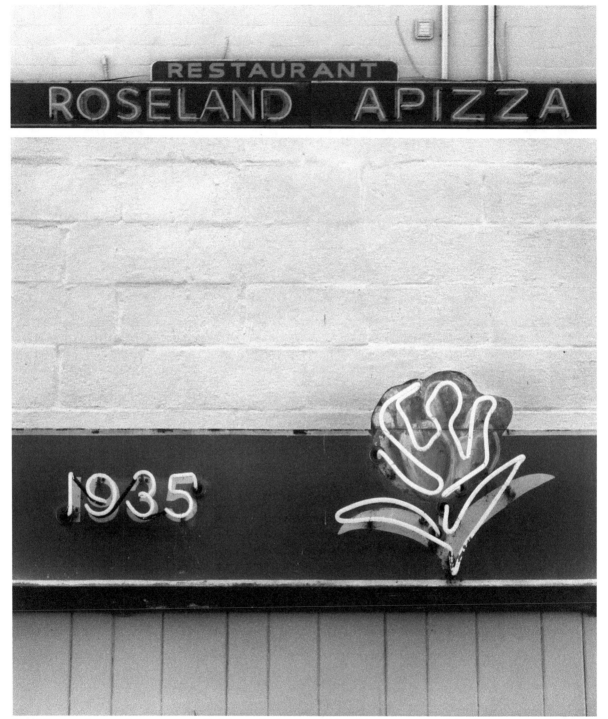

New Haven is known for its pizza—called "apizza"—but one of the oldest purveyors of the distinctive charred-crust and oblong-shaped pies can be found in Derby, Connecticut. In the 1940s, Lina S. Lucarelli took over Roseland Apizza, which her father, John Scatolini, opened in 1935. She ran the restaurant with her husband, Nazzareno "Bocci" Lucarelli, and her children, and it is still in the family.

The State Theatre opened in 1939 in Jewett City, Connecticut. The theater's original Art Deco marquee can be seen in photographs as recently as 1977, but all that remains today is a single roof-mounted sign above the remnants of an old backlit plastic display. The theater closed and reopened several times between 2003 and 2006, when it shut its doors for good.

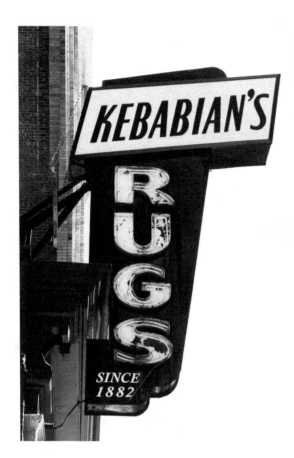

John Couzu Kebabian came to the United States from Turkey in 1882 to finish his education. He began selling Oriental rugs to pay his tuition at Yale University and founded Kebabian's Rugs in New Haven, Connecticut, in 1888. Today, his great-grandson John P. Kebabian Jr. owns the fifth-generation business, which is the oldest importer of Oriental rugs in the country.

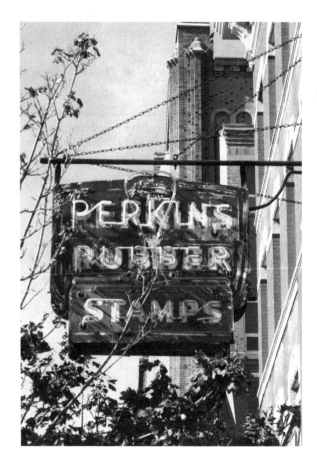

A.D. Perkins is the oldest retailer in New Haven, Connecticut, founded by Arthur D. Perkins in 1876 to make rubber stamps. The company moved into its current address in 1951 and installed a double-sided neon sign with the outline of a rubber stamp. Unfortunately, the branches of a street tree planted a bit too close kept breaking the neon tubes, and the shop eventually stopped fixing the sign.

Josephine and Vito Salerno started selling pizza in Bridgeport, Connecticut, in 1947. They moved their business to its current Stratford location in the Cutrufello's Creamery building in 1970 and renamed it Salerno's Apizza (pronounced "ahh-beetz"). Carlo Salerno took over the family business after his father's death.

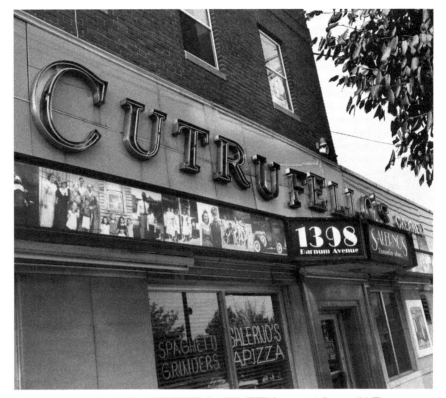

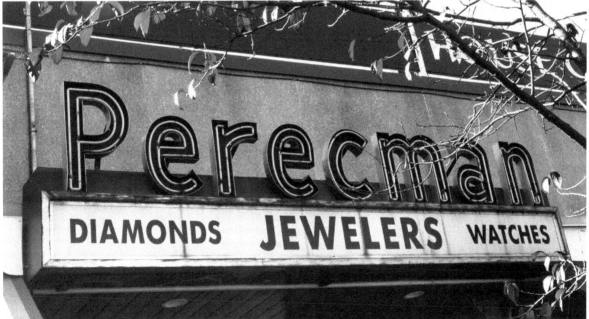

Polish-born master watchmaker Gershon Perecman was a Holocaust survivor. He and his family immigrated to the United States after World War II and opened a jewelry shop in New Haven, Connecticut. Perecman Jewelers moved to its current location in the city's Westville neighborhood in 1958, and Perecman worked alongside his father (who joined his son's business). Today, Perecman's children run the store.

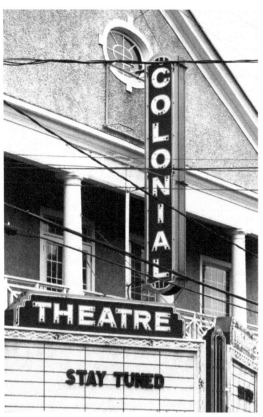

The Colonial Theatre opened in North Canaan, Connecticut, in 1923. First known as the Casino, the three-story venue housed a movie theater, a ballroom, and a bowling alley. The Colonial closed in 1997 when owner and operator Shirley Boscardin died. A community-based nonprofit subsequently purchased and restored the theater, which now hosts live events and occasional movies.

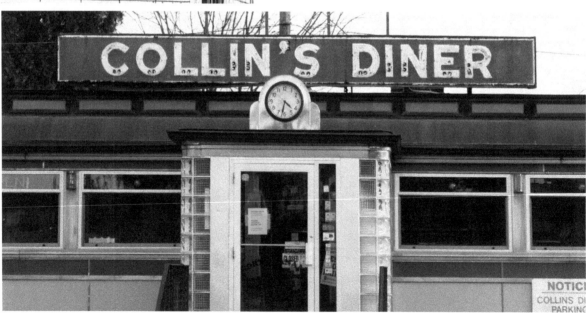

Collin's Diner is a Jerry O'Mahony dining car from the early 1940s in North Canaan, Connecticut. Aida and Mike Hamzy bought the diner in 1969 and infused the traditional American menu with specialties from their Lebanese heritage, like hummus and tabbouleh. Today, their children run the diner. Both the Colonial Theatre and Collin's Diner are part of the Canaan Village Historic District.

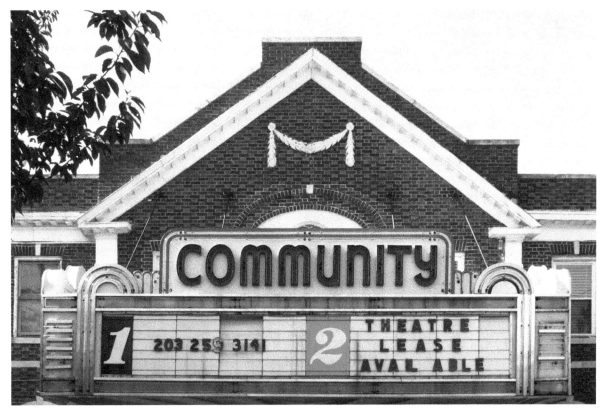

The Community Theatre opened in Fairfield, Connecticut, as a vaudeville house but soon switched exclusively to screening films. A 1933 renovation introduced an Art Deco neon marquee. The theater closed in 2001 to reopen as a nonprofit venue, but it closed again in 2011.

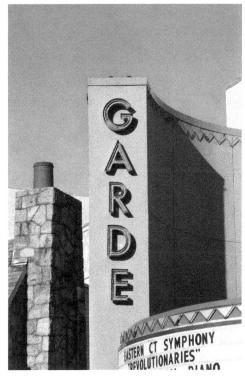

The Garde Theatre opened in 1926 in New London, Connecticut, with a screening of *The Marriage Clause*. Named after local businessman Walter Garde, the 1,600-seat Moorish-themed movie palace featured murals by artist Vera Leeper. Leeper combined painting and bas-relief techniques, applying a product called "morene" to the walls with a knife. The nonprofit Garde Arts Center saved the theater from demolition in the 1980s and restored its lavish decor.

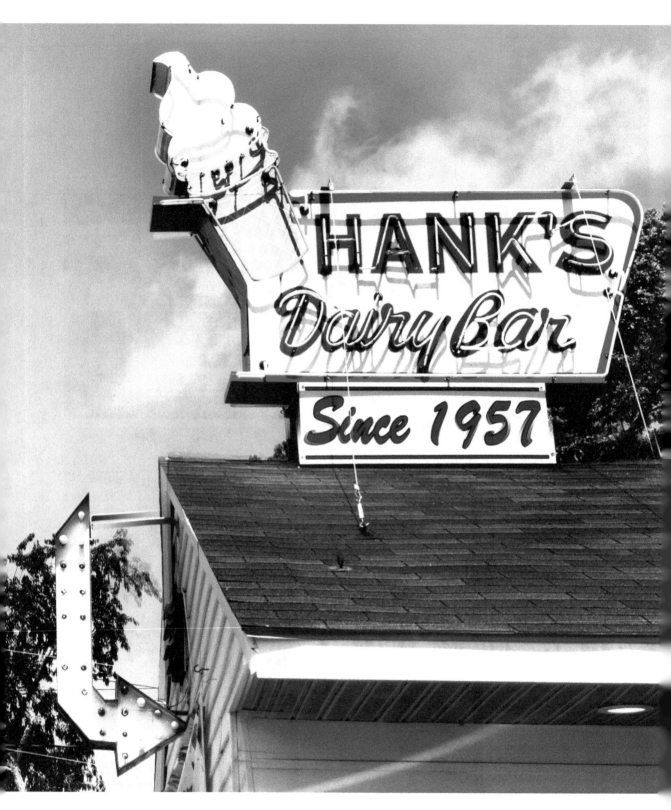

As the sign says, Hank's opened in 1957 in Plainfield, Connecticut. Hank Zurowski sold produce at the time, and he founded the dairy bar to supplement his business during the slow summer months when his customers grew their own vegetables. Within a few years, an expanded menu included hamburgers, hot dogs, and French fries. Hank's fabled coleslaw recipe remains a closely guarded family secret to this day.

The word "skating" is still visible on this rusty sign in New Haven, Connecticut. The sign sits on a building originally occupied by the White Motor Company, an Ohio-based auto manufacturer. The auto dealership closed in 1945, and the building found a second life as a roller-skating rink. The Eli Skating Club operated into the mid-1950s, and the evocatively named New Haven Roll-A-Round held sway through the 1960s. Locals say the rink's wooden floorboards are still intact.

Four

VERMONT AND
NEW HAMPSHIRE

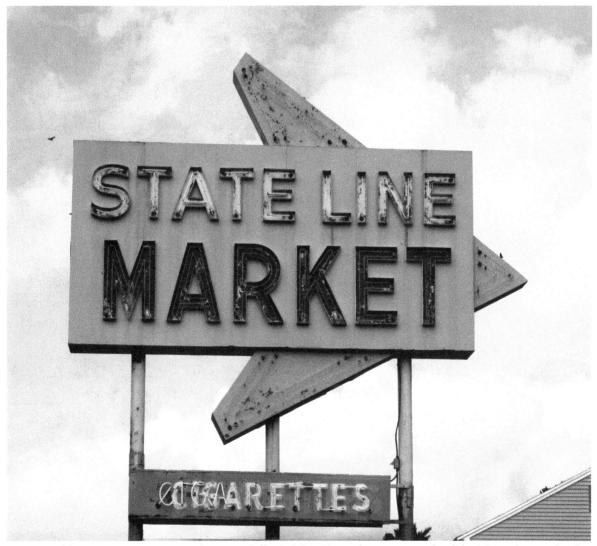

Don's World Famous State Line Market is in Pelham, New Hampshire, just north of the Massachusetts border. A freestanding sign with a giant neon arrow directs customers to this convenience store, which has been in the Magiera family since the 1950s.

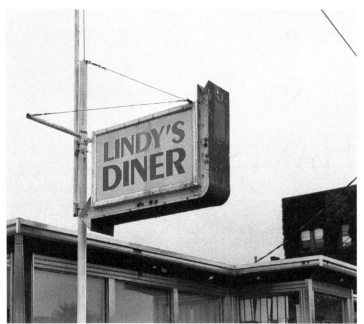

Lindy's Diner arrived in Keene, New Hampshire, on a flatbed truck in 1961. In 1973, George and Arrietta Rigopolous purchased the diner from the Chakalis family, who were the original owners, and encouraged presidential candidates to visit Lindy's during their campaign stops. Current owners Nancy Petrillo and Charlie Criss bought the establishment in 2003 and retained the diner's political tradition.

The Birdseye is a 1940s-era Silk City Diner that found its way to Castleton, Vermont, in 1960. Its namesake was a wood-framed diner that had burned down, and over the next three decades, the diner was variously called the Campus Diner, Jim's, and T.J.'s. Pam and John Rehlen bought the diner in 1995, restored its 1940s look, and revived the original name.

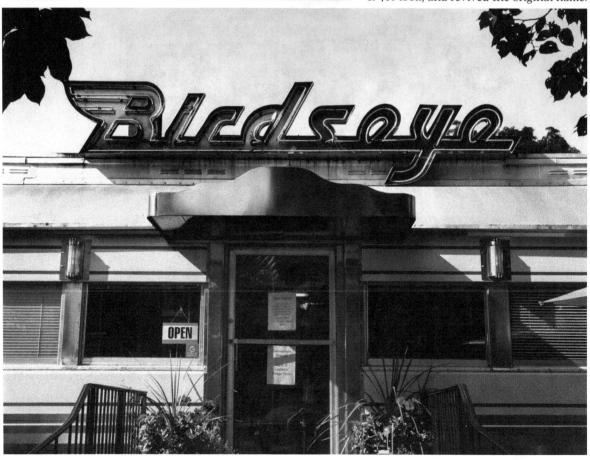

When Henry's Diner opened in Burlington, Vermont, in 1925, diners had a rough reputation. To change that image, original owner Henry Couture added "feminine frills" like window boxes and awnings. Henry's soon became "the fashionable place to dine for scions on the hill and for ordinary working folk," according to the menu. To further convey sophistication, Henry's was encased in green stucco in 1935 to create the look of a Spanish restaurant.

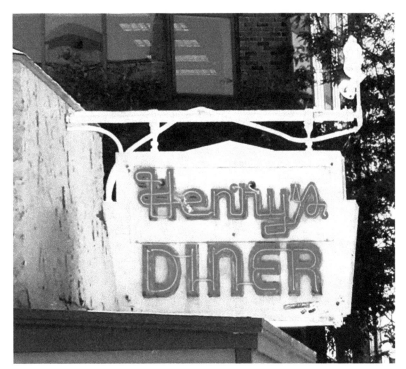

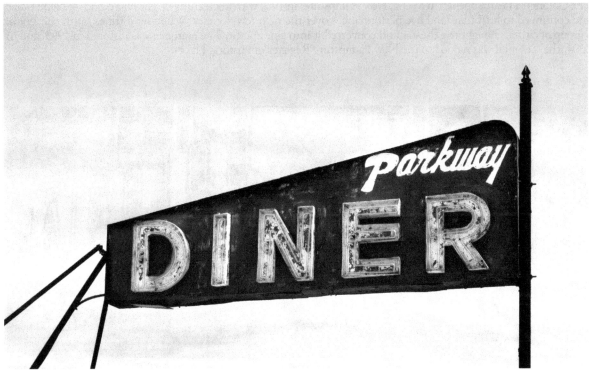

The Parkway Diner opened in South Burlington, Vermont, in the 1950s. The diner changed hands several times and was renamed Arcadia Diner when the owners of Henry's briefly took over. After a lease dispute forced the Arcadia to close, a new owner acquired the Worcester Lunch Car (No. 839) in 2013 and restored its original name.

The Colonial Theatre opened in Keene, New Hampshire, in 1924 with a screening of *The Hunchback of Notre Dame* and continued to host films and live performances over the next few decades. When hard times hit in the 1990s, a group of citizens bought the theater and converted it into a nonprofit. The marquee was restored in 1999, and in 2004, the Colonial was named to the New Hampshire Register of Historic Places.

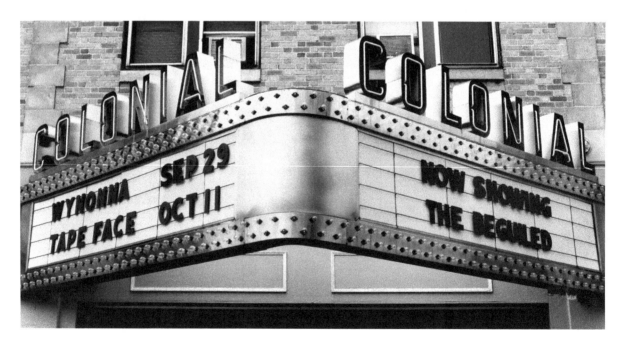

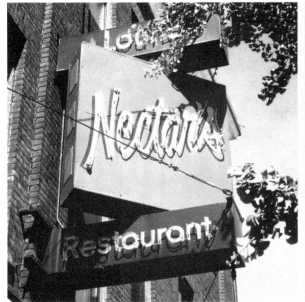
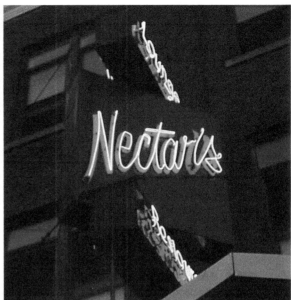

Nectar's is famous for two things: Gravy fries and the popular jam band Phish. Nector Rorris opened the Burlington, Vermont, music spot in 1975. Phish, then an unknown local band, began playing regular gigs at Nectar's in the 1980s, and their 1992 album *A Picture of Nectar* is a tribute to Rorris. Rorris sold Nectar's in 2003, and a local consortium owns the lounge today.

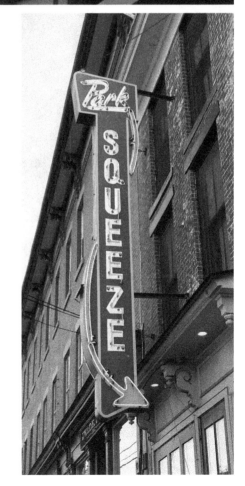

Vergennes is the oldest city in Vermont and also the smallest. The late restaurateur Michel Mahe opened the Park Squeeze on the city's historic Main Street in 2013, taking over the spot and the name of the previous occupant. That prior establishment inherited the neon sign from the old Park Restaurant and reworked the lettering to reflect the new name.

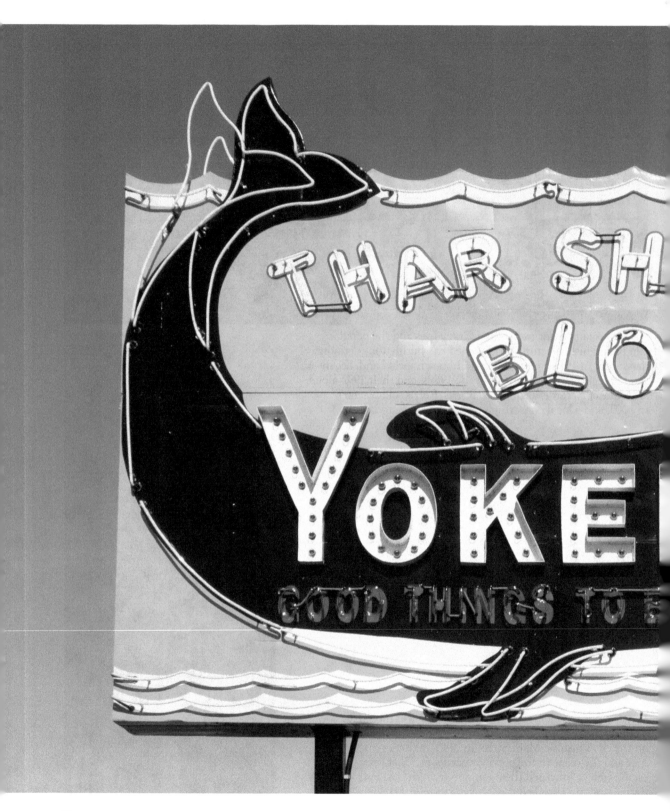

Yoken's Restaurant closed in 2004, and the building was razed. However, its landmark "Thar she blows" sign was saved. A group of local businesses known as the 4 Amigos LLC, along with the Newburyport Five Cents Savings Bank, paid to have the sign refurbished and reinstalled close to its original location in Portsmouth, New Hampshire. The Portsmouth Sign Company rehabilitated the sign.

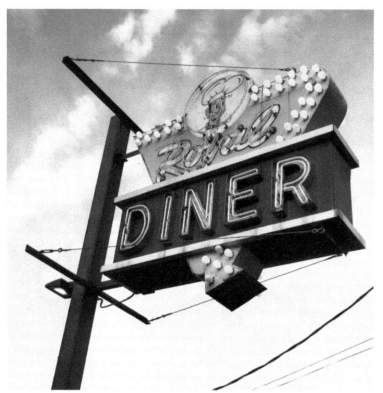

Todd Darragh bought the Royal Diner in 1990 and added the name Chelsea in honor of Chelsea House, a folk music venue previously on the site in West Brattleboro, Vermont. Darragh and co-owner Janet Picard serve farm-to-table food at the diner, including produce from their garden and eggs from their hens. The Chelsea Royal Diner is a Worcester Lunch Car (No. 736) from the late 1930s.

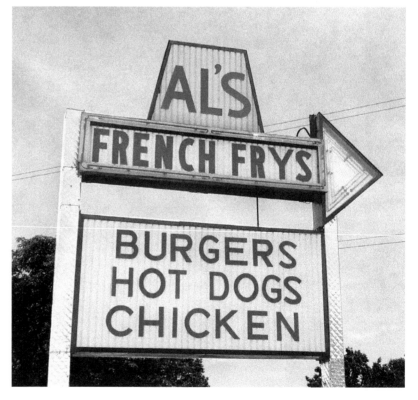

Genevieve and Al Rusterholz started Al's French Frys in a trailer on the shores of Lake Champlain in the 1940s. Genevieve takes credit for the atypical spelling; she thought F-R-Y-S was "appealing and different." Eventually, Al's moved to South Burlington, Vermont, which was still a rural community. Brothers Bill and Lee Bissonette purchased Al's in the early 1980s. While the surrounding farmland has disappeared, the "French Frys" have not changed.

Originally known as the Playhouse Theatre, the Capitol Theatre opened in Montpelier, Vermont, around 1926. The theater received its current name around 1940, and today, it is operated by FGB Theaters, a small Vermont chain.

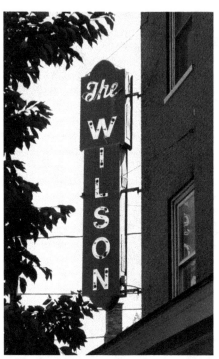

The Wilson was previously a hotel in Burlington, Vermont. The Committee on Temporary Shelter purchased the building in 1984 and turned it into single-room occupancy units for people making the transition from life on the streets to independent living.

Effie Ballou opened the Wayside Restaurant in 1918, preparing meals at home and carrying them downhill to the roadside spot in Montpelier, Vermont. Eugene and Harriet Galfetti bought the Wayside in 1966. Today, their daughter Karen and her husband, Brian Zecchinelli, continue the family tradition, mixing traditional offerings like salt pork with contemporary touches like gluten-free bread.

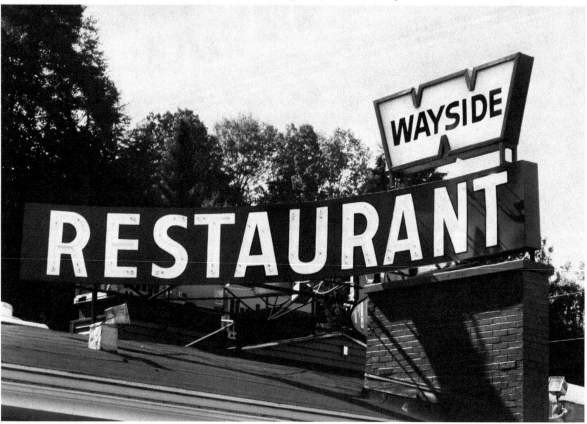

The Town Line Motel was built in 1940 in Meredith, New Hampshire, just north of Lake Winnipesaukee. The motel had 18 units and a swimming pool; vintage postcards identify Rachel and Joe Rosa as the owners. The property changed hands multiple times over the years, and only the sign remained in 2017.

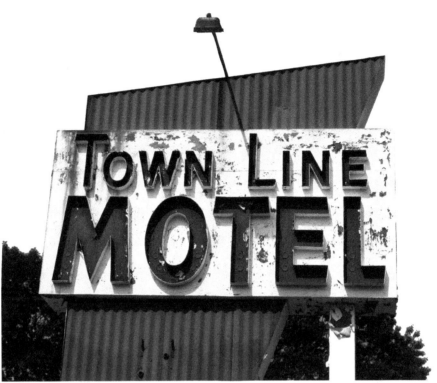

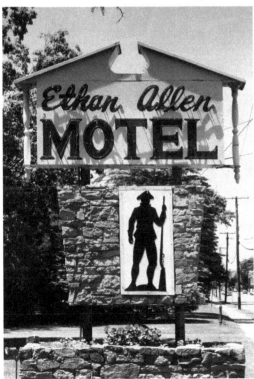

In South Burlington, Vermont, the Merrill family has been welcoming travelers to the Ethan Allen Motel since 1953.

Gauthier's Pharmacy opened on Railroad Street in St. Johnsbury, Vermont, in 1932 and is still an independent pharmacy. The "DRUGS" sign was manufactured by Flexlume Signs sometime between 1930 and 1941. Flexlume built mostly multiple production signs at that time, and the pharmacy owner likely ordered the sign out of a catalog.

The Flynn Theatre opened in Burlington, Vermont, in 1930 as a vaudeville house but quickly switched to showing movies. The theater began to suffer in the 1950s, falling victim to competition from television and the rise of suburbia. A nonprofit formed in 1980 began to restore the once-grand theater, and today, the renamed Flynn Center for the Performing Arts hosts live performances and educational programs in an Art Deco setting.

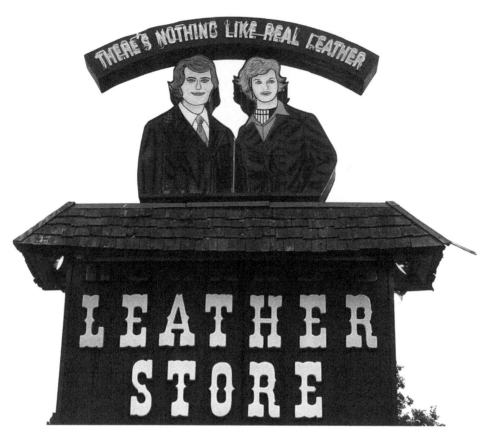

Howard Small founded Howard's Leather Store in 1952 to sell horse supplies and Western-style clothing. His daughter Jane and her husband, Joe Plante, opened the store's current location in Spofford, New Hampshire, in 1966. Today, Small's granddaughter Carla and her husband, Mike Mansfield, run the family business.

Joseph Shaffe established Shaffe's Men's Shop in Bennington, Vermont, in 1932. The shop changed location several times and settled into its current Main Street spot in 1963. Shaffe's son David took over the business in 1975. Shaffe's is included in the Downtown Bennington Historic District.

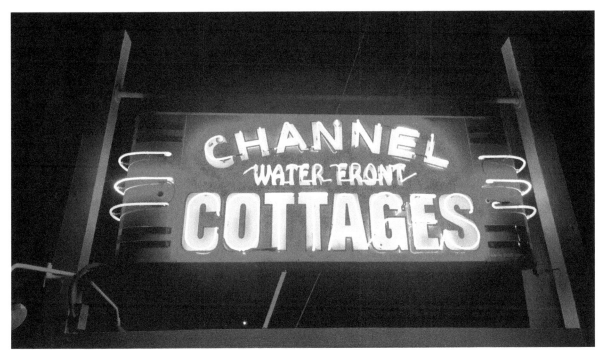

The Channel Waterfront Cottages in Laconia, New Hampshire, date from the 1920s. Ernestine and Archie DePine bought the property in 1945, and they sold it to their son and daughter-in-law Maurice "Joe" and Eleanor DePine in 1969. Joe changed the name from Channel Cabins to Channel Motor Court. José DeMatos purchased the seasonal business in 1992, which now includes a dozen cottages on the Weirs Beach Channel and a vibrant red freestanding neon sign. (Above, courtesy of José DeMatos.)

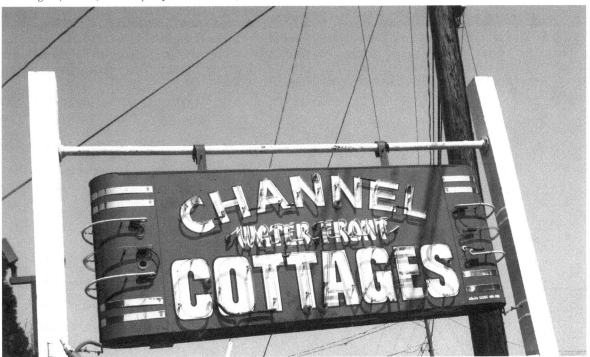

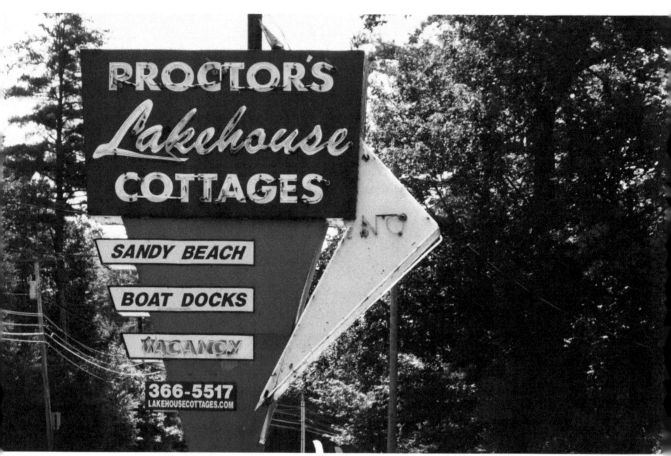

John and Mary Proctor bought the Pine Tree Lodge in 1947 in Laconia, New Hampshire. They renamed the property and expanded it over the years. Their daughter Jean Ginn sold the establishment to Fred Clausen in 1999. Clausen and his wife, Maureen, ran the business, by then called Proctor's Lakehouse Cottages, for 15 years and turned over daily operations to their son Patrick Clausen and daughter-in-law Gladys in 2014.

The 1832 building housing Dot's Restaurant was once the post office for Wilmington, Vermont. John Reagan acquired the spot in 1980 and changed the name to Dot's Restaurant. In 2011, flooding from Tropical Storm Irene destroyed Dot's, and the community banded together to help Reagan and his wife, Patty, rebuild. The restaurant reopened in 2013.

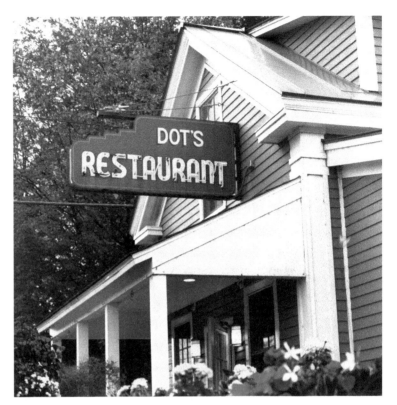

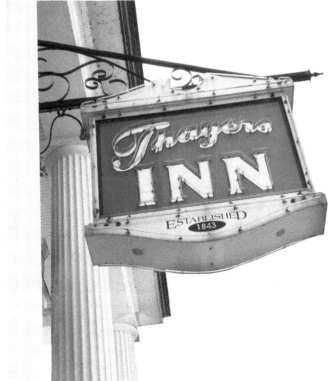

Thayer's White Mountain Hotel opened in Littleton, New Hampshire, in 1850. The hotel gradually simplified its name, dropping the apostrophe and White Mountain designation, and is now known as Thayers Inn. The Greek Revival building has hosted presidents from Ulysses S. Grant to George H.W. Bush. And Thayers can claim a few cultural icons as guests as well, from P.T. Barnum—accompanied by Gen. Tom Thumb—and notorious socialite Harry K. Thaw (best known for murdering architect Stanford White in New York City in 1906).

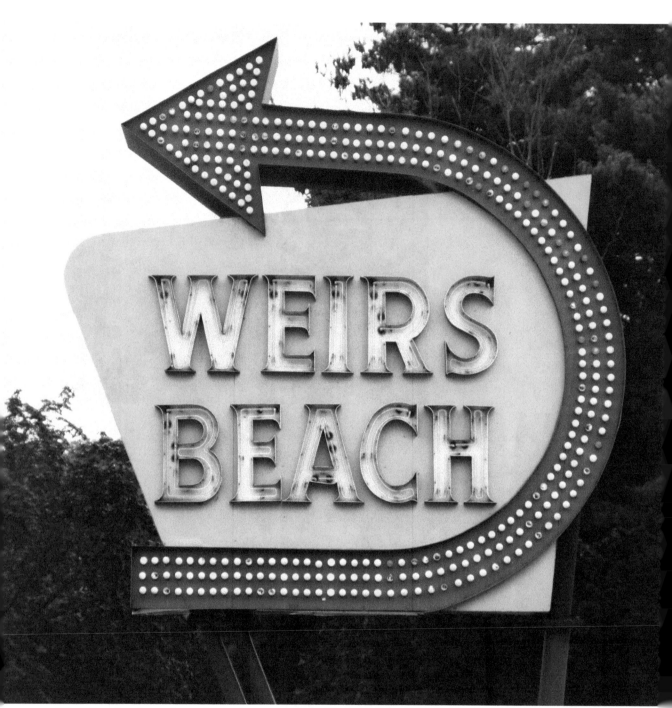

The Weirs Beach sign has welcomed visitors to Lake Winnipesaukee in New Hampshire since 1956. The two-sided sign has 200 feet of neon tubing and 696 chaser bulbs that create the illusion of motion in the sign's arrow. Time took its toll, and by 2002, it was in danger of being torn down. Instead, several local businesses helped raise funds to restore the sign. The power source was changed from overhead utility lines to an underground cable as part of the restoration, and the sign was moved to improve the traffic flow on US Route 3. Its color scheme was also changed from the original yellow and black to the current blue and red.

Five

MAINE

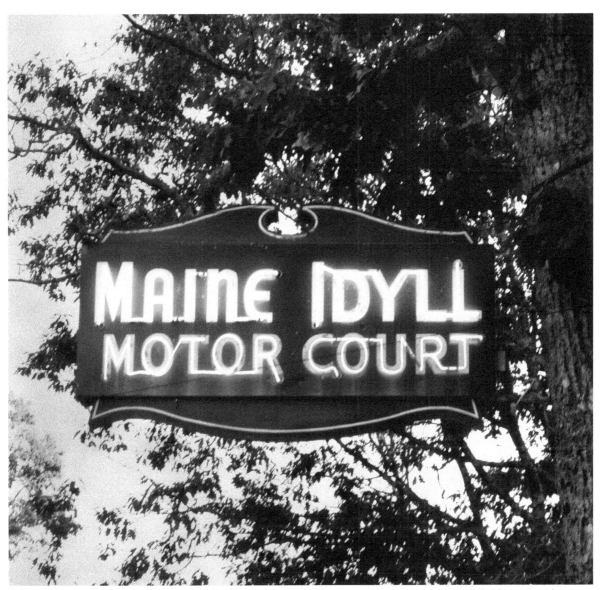

When Americans took to the open road in the early 20th century, most simply camped in fields or rented a room in a "tourist home." By the 1930s, tourist courts began to dot the nation's roadways. These accommodations offered a string of cottages and amenities like filling stations and cafés. Family owned since the 1930s, the Maine Idyll in Freeport carries on this tradition with 20 tourist bungalows.

Like many New England diners, the Brunswick Diner has traveled a bit. The eatery began its culinary career in Norway, Maine, and moved to Brunswick in 1946. A simple neon pylon sign catches the attention of drivers on US Route 1, and a clock above the entrance (not shown here) reminds customers that it is time to eat.

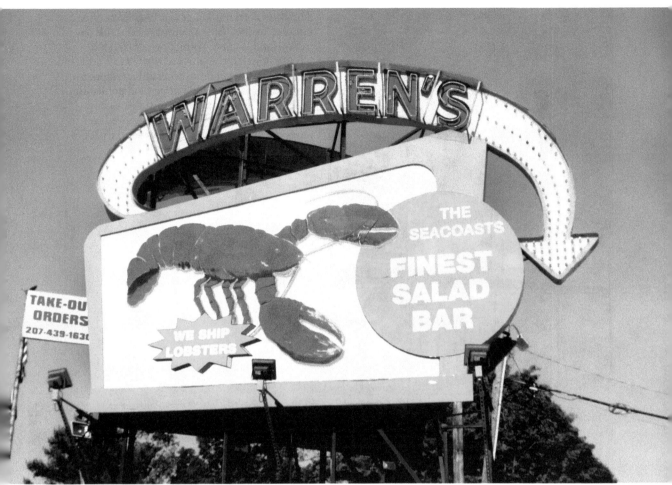

Warren "Pete" Wurm opened a walk-up seafood stand in 1940 when lobster was 25¢ a pound. Located in Kittery, Maine, on the shores of the Piscataqua River, Warren's Lobster House has grown from a six-stool hut to a full-service restaurant seating hundreds of customers.

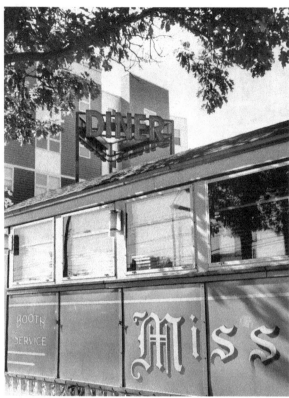

The Miss Portland Diner is a 1949 Worcester Lunch Car (No. 818) serving breakfast all day in Portland, Maine. Former owner Randall Chasse donated the diner to the City of Portland in 2004 after several unsuccessful attempts to sell the eatery. Portland native (and publishing executive) Tom Manning stepped in to buy the diner from the city in 2007, restored the property, and reopened Miss Portland in 2008.

This freestanding neon sign is all that remains of the Queen City Motel in Bangor, Maine. Robert Treworgy, of Bangor Neon, installed the sign in the 1960s. Treworgy founded the neon shop in 1948, and the company is still in the family.

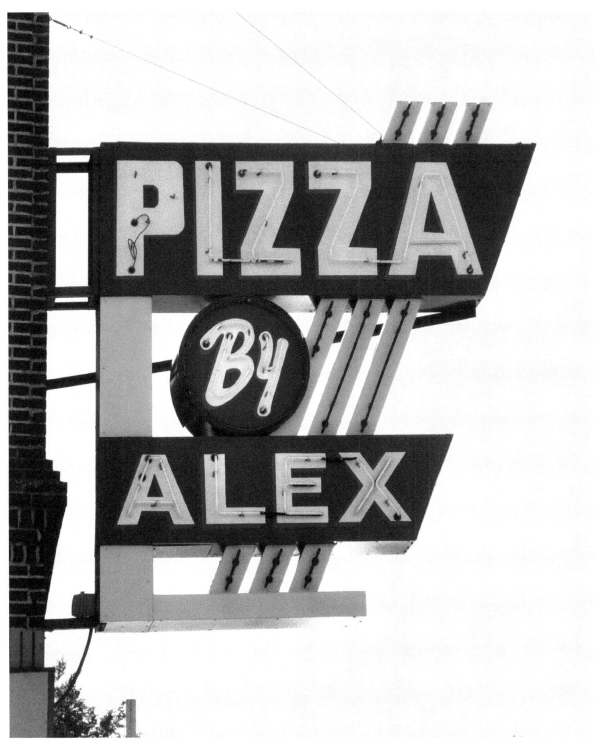

Alex Mantis opened Pizza by Alex in Biddeford, Maine, in 1960. A few years later, the establishment moved to its current location, also in Biddeford. The restaurant stayed in the family, and today, Alex's nephew Andy Mantis runs the business.

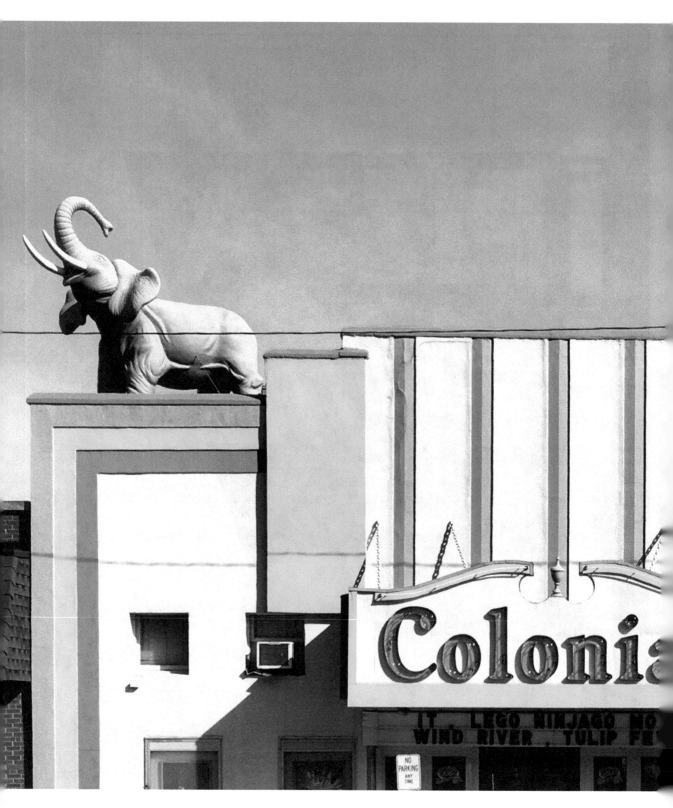

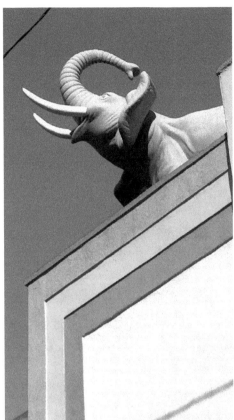

The Colonial Theatre is the only building in Belfast—and possibly all of Maine—with an elephant on its roof. The theater opened in 1912, but the neon marquee was part of a 1947 renovation. The elephant came from Perry's Nut House 50 years later and answers to the name Hawthorne. The Colonial is in the National Register of Historic Places as part of the Belfast Historic District.

The Center Theatre was built around 1940 in Dover-Foxcroft, Maine. The theater closed in 1971 and stayed shuttered for almost three decades until a community-based nonprofit purchased the property in 1999, began renovations, and created the Center Theatre for the Performing Arts. In addition to a year-round schedule of arts, education, and cultural programming, the theater hosts the annual Maine Whoopie Pie Festival to celebrate the state's official treat.

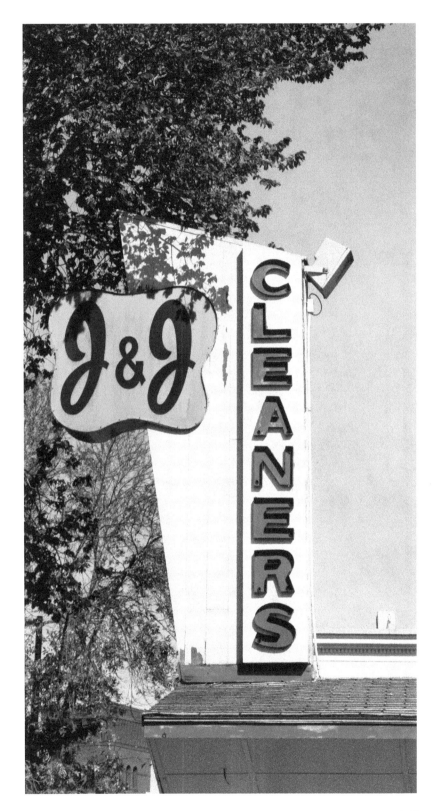

Joe Bernier Sr. and Jake Pinette founded J & J Cleaners in Brunswick, Maine, in 1953. James and David Machesney purchased the company in 1996, and James Machesney Jr. took over the business in 2010. J & J Cleaners is part of the Brunswick Commercial Historic District, which was added to the National Register of Historic Places in 2016.

Now one of the six remaining drive-in theaters in Maine, the Prides Corner Drive-In opened in Westbrook in 1953. John Tevanian ran the theater with the help of his brothers, and his son Jeffrey Tevanian operates the business today. The theater closed for the 2016 season to make the transition to digital technology but ushered in 2017 with showings of family-friendly fare.

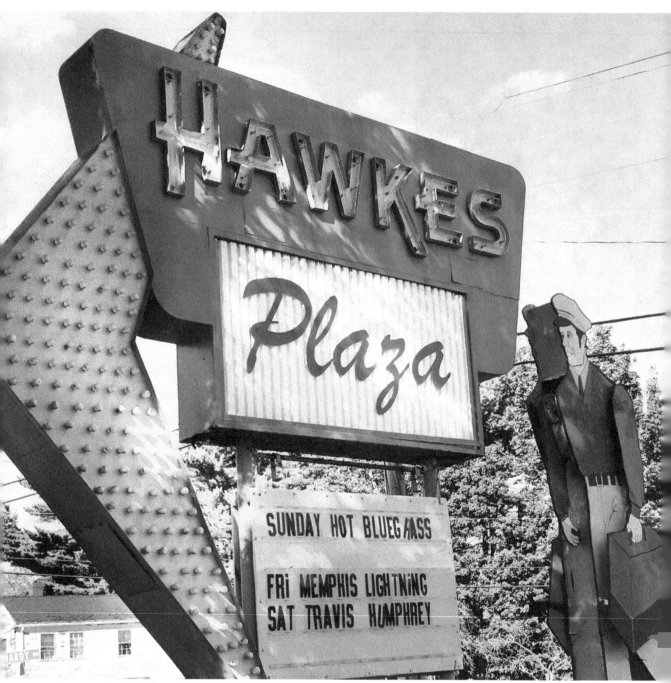

A man of many talents, bluegrass musician Al Hawkes built this sign in 1962 in Westbrook, Maine, on the site of his recording studio and television repair shop. The prominent display incorporated a jaunty 13-foot figure carrying a toolbox in one of its mechanical arms, which swung back and forth. The sign stopped moving in 1989 when state highway officials deemed the motion a distraction to drivers on Route 302. In 2016, Bill Umbel opened a restaurant and music club on the property. In a nod to the location's history, he named the spot Lenny's to honor the late Maine guitarist Lenny Breau, who recorded at Hawkes's studio in the 1950s. Umbel restored the sign, including the mechanical "Walking Man," as the repairman is known locally.

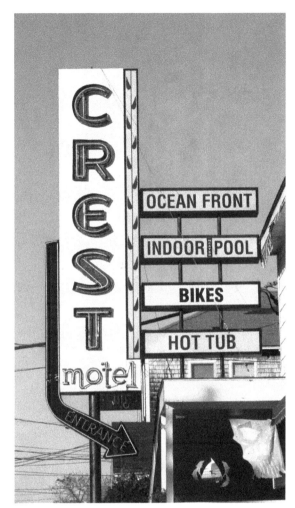

Old Orchard Beach has been a popular Maine tourist destination since the 19th century. The town's steel pier, first built in 1898, included a casino that hosted everyone from Benny Goodman to Frank Sinatra in its heyday. The Pier Casino Ballroom was torn down in the 1970s, and the Blizzard of 1978 destroyed the rest of the pier. Rebuilt in 1980, the pier currently hosts small shops and restaurants. Many of the town's neon signs are long gone, but a large sign, originally built in 1964 and recently replaced, still welcomes guests to the Crest Motel. Nearby, remnants of an old neon sign are visible on the roof of the Windward Sail Motel.

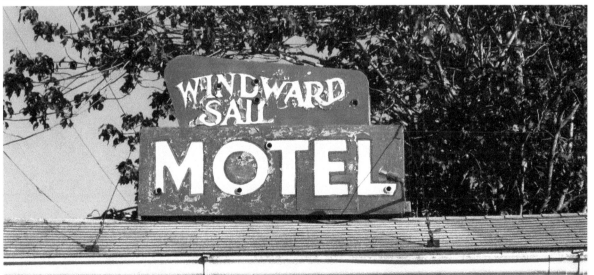

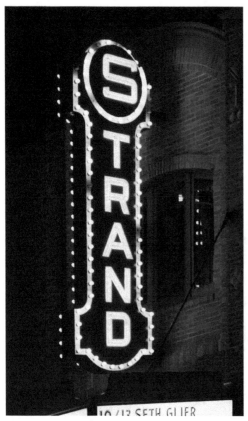

The Strand Theatre opened in Rockland, Maine, in 1923 with a screening of the silent film *My Wild Irish Rose*. Local businessman Joseph Dondis owned the theater until his death in 1940, when his wife, Ida, took over operations. After Ida retired in 1980, her son Meredith became manager; the theater continued to show first-run films through the 1990s. Meredith retired in 2000 and sold the theater. The Strand began to decline after the change in ownership and soon went dark. In 2004, the Simmons family purchased the theater and restored the local landmark. The theater was organized as a nonprofit in 2014. This new status brought the Strand full circle as Jo Dondis, granddaughter of Joseph and Ida, was named to chair the board of directors for the Friends of the Strand Theatre. Now listed in the National Register of Historic Places, the Strand Theatre currently offers a mix of films and live performances.

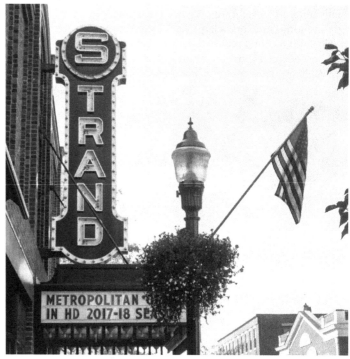

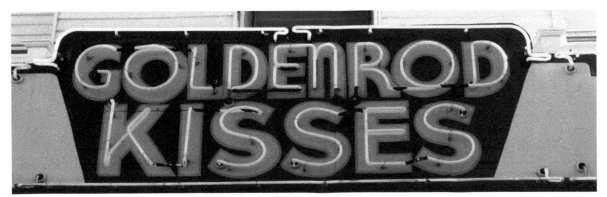

Edward and Mattie Talpey established the Goldenrod in 1896. The York Beach, Maine, shop quickly became famous for its saltwater taffy—dubbed "Goldenrod Kisses"—pulled by hand in the front window. Although the taffy-pulling process is now mechanized, the Goldenrod still makes those kisses—about eight million pieces of taffy a year—and people continue to line up at the windows to watch.

Fresh from a stint in federal prison for bootlegging, George McKay opened the Criterion Theater in Bar Harbor, Maine, in 1932. Locals still talk about the speakeasy that operated in the Criterion's basement, and the theater is a stop on the Prohibition-themed tours offered to the city's visitors. The Art Deco theater was placed in the National Register of Historic Places in 1980, but management and maintenance problems led to intermittent closures over the years. A nonprofit restored the theater in 2015.

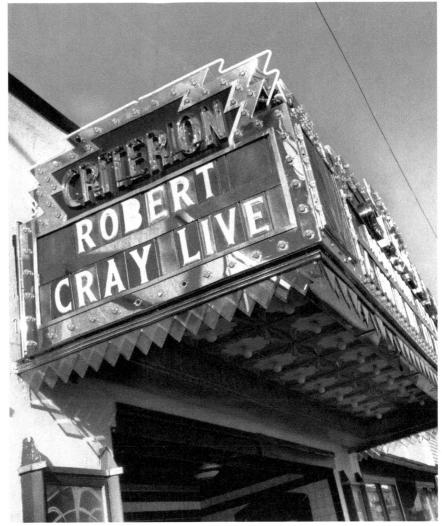

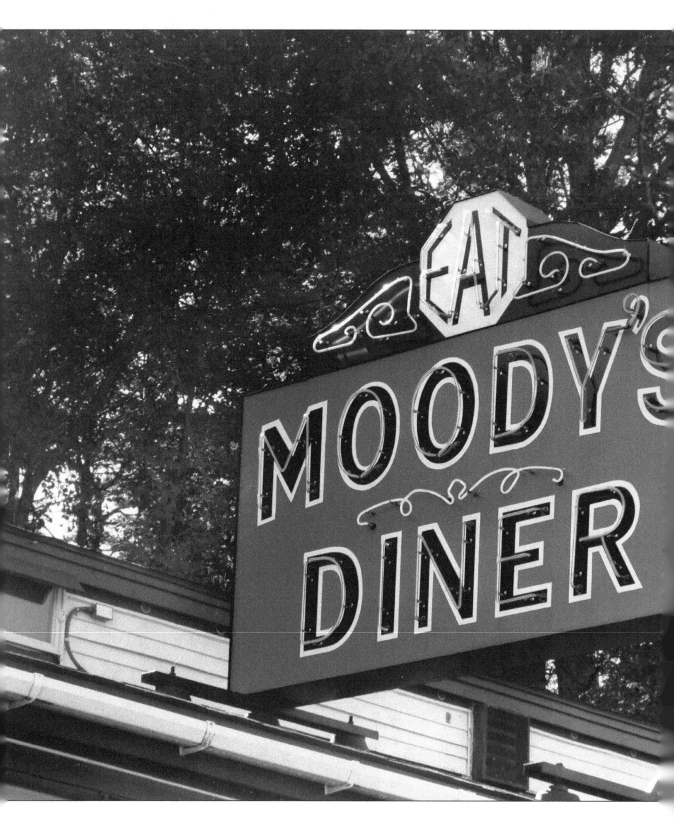

Bertha and Percy Moody opened three tourist cabins in Waldoboro, Maine, in 1927. A lunch wagon soon followed and eventually grew into the Moody's Diner that people know today. A fourth generation of the Moody family is still involved with the diner. Moody's original neon sign is in a private collection, and a replica was installed on-site.

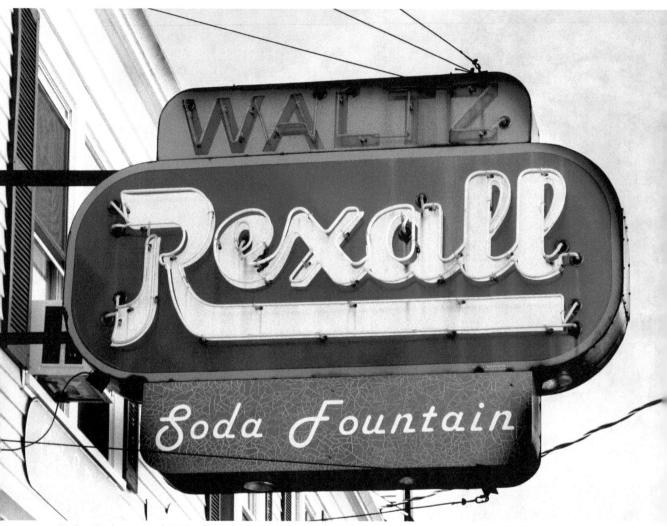

Perley Waltz opened Waltz Pharmacy, complete with soda fountain, in Damariscotta, Maine, in 1948. After the pharmacy closed in 2011, the soda fountain was renovated and incorporated into the Renys department store next door. The vintage Rexall sign was modified slightly to advertise the soda fountain after the change.